Wedding Photography:

After 1000 Weddings

Find Taylor Jackson:

YouTube:
http://www.youtube.com/taylorjacksonphoto

Instagram:
https://www.instagram.com/taylorjackson/

Full Length Courses:
https://www.taylorjacksoncourses.com/

Focal Websites:
https://www.bookfocal.com/taylor

Wedding Photography: After 1000 Weddings

Taylor Jackson

Thank you to the team at Focal (bookfocal.com) for helping with the creation of this book.

For information about permission to reproduce any selections from this book, please email taylor@taylorjacksonphoto.com

Cover design by Kimi Moore

Editing by Cary Jones and Harry Davies

Thank you to my wife, Lindsay Coulter, for always supporting my strange and unusual dreams.

Contents:

An Introduction

After photographing over one thousand weddings in my career as a photographer, I've learned a few things.

I've learned things that have helped me book seventy weddings per season consistently.

I've learned things that have helped me travel to every continent, including Antarctica.

I also managed to do it all while being incredibly introverted and shy.

Throughout this book, I will share what I've done to go from a struggling server at an Outback Steakhouse in Canada to someone who has created a full-time business in wedding photography. I'll also share my secrets for creating a full-time business that doesn't take over your life.

For me, I value time freedom the most. Of course, Saturdays are for weddings, but you can customize the rest of your week.

To define time freedom, it is being in control of when and where you work.

Want to spend a few days at the cottage? No problem, you don't have to ask anyone for time off. Saw a cheap last-minute vacation package to a Caribbean island? Go for it, and answer your emails from the pool. Running your own business makes your life incredibly customizable and fun.

The financial side is also good. If you're averaging $3000 - $4000 per wedding and photographing sixty weddings, your business makes $210,000 annually. Not bad for a job that also comes with time freedom and flexibility.

With all of this said, not everything has been perfect along the way. My hope with this book is that I can save you some of those struggles I went through.

Whether you're year zero into business or already photographing busy seasons, there will be something in this book for you.

Thanks for spending this time with me, and if you enjoy this book, please leave a review for me. I would appreciate it.

You can also tag me on Instagram at @taylorjackson if you'd like. If I see it, I will reshare it.

1

My First Wedding

The first wedding I ever photographed was a disaster. I booked it from Craigslist. For free. Picture this:

I'm sitting alone in my blue 1995 Ford Taurus in one of the sketchiest neighbourhoods in Toronto.

There is no sign that a wedding is happening at this address.

All curtains in the house are closed. No one has gone in or out in the twenty minutes I've been sitting here.

My life savings are in the camera gear on the seat next to me.

No insurance, because I don't know how to run a business.

At this point, I had been trying to become a wedding photographer for over a year with no actual bookings. I was young, awkward, and incredibly introverted. I knew how to talk to the skateboarders, snowboarders, and bands I'd been photographing up until this point. But, unfortunately, I'm not cut out for wedding communication. To add to that, I hated wearing dress pants and dress shoes.

At this point, you might be asking, 'Why did you even go down this path?' In all honesty, it was money and a stable career.

There was a moment when I typed into Google, 'What are the best-paying jobs in photography.' Of course, wedding photography was always high on the list.

After years in the action sports and concert photography scene, I was sick of getting paid in free t-shirts.

I was in college for Computer Programming and graduating soon.
Part-time, I worked as a server at Outback Steakhouse.

I took a few nine-to-five co-op jobs during my Computer Programming years and quickly realized that I hated that life structure. If I finished my work by one o'clock, why did I have to stay until five?

Serving at Outback Steakhouse was fun, and in many ways, it prepared me to run my own business.
In Canada, like in America, servers are paid pennies hourly with the restaurant relying on their customers to make up the wages through tips.
Dumb concept aside, it creates an exciting game for an eighteen-year-old.
Sometimes you go to work, get great customers, and make good money. Maybe $300 or $400 in a night if you're closing.
Sometimes you go in, roll cutlery for three hours for your nine cents an hour, and get sent home because no one is coming in the door.

This randomness of the ups and downs is very accurate to being an entrepreneur. You have to learn to handle that mentally.
When you get those good nights, know there will be bad ones. So don't go out and blow all your cash because you have it.

In the wedding photography business, this cycle lasts twelve or sixteen-month periods. So it's even harder to come to terms with the same mentally. Maybe you book twenty weddings in February and take $50 000 in deposits, then don't see a single inquiry for March and April. Zero dollars made, but your money was still being spent on marketing and your business. Those months you don't make money you still spend money.

Soon, when May and June come around, you start photographing those weddings you booked and taking those final payments. Suddenly you're too busy to spend any of the money you're making and you feel comfortable financially. Then December comes, and you make nothing for the entire month going into the holidays.

You can see how this messes with your mind if you're playing the day-to-day finance game, not looking at it by years and spending accordingly.

It doesn't have to be scary though.
If done correctly, you're looking at a $100,000 - 300,000 business with very few expenses per year.

This book will give you the advice you need to get to that spot and stay there.

Now back to my first disaster wedding.

I sat in my 1995 Ford Taurus looking at flashcards of wedding poses and reviewing my shot list.

If you go to www.taylorjacksoncourses.com/book, there's a link to my shot list as a gift to you for spending this time with me.
I exited my vehicle, walked towards the house, and knocked on the door.
The door opened into the darkest house I'd ever seen in my entire life.

At this point, I thought I was about to be robbed.
"Free Craigslist photographer, brought to the house to shoot a wedding, all wedding gear stolen."
Yeah, that makes sense.

The person opening the door told me, "they're all down in the basement."

Super. Even sketchier.

I went down the stairs into the even darker basement.

I hadn't told anyone the address I was going to today. Safety never even crossed my mind. I was just excited to be taking wedding pictures.

Leading up to this day, I had spent hours and hours learning everything I could about wedding photography. Nothing could have prepared me for this, though.

Rounding the corner at the bottom of the stairs, I see a wedding dress.

I relax a little bit.

The couple is seated on the couch, being photographed by another photographer.

Okay, this is strange.

Then there's another photographer and three assistants.

Did they just hire every free or cheap wedding photographer on Craigslist to this basement to battle it out?

At this point, all of my learning and training falls apart.

I have no idea what's going on.

This moment is the clearest memory of the entire day.

What appeared to be the lead photographer was shooting on a super wide Tokina 11-16mm lens. This lens was not a wedding lens I had learned of. It's great for skateboarding and bands but a weird wedding choice.

Then it got weirder.

One of the assistants held a huge Quantum flash kit with an external battery, pointing it directly at a tiny handheld reflector and bouncing it back at the couple.

It sounded like an old-time portrait studio with the 'thunk' from the light and then the high-pitched recharge frequency.

The photographer yelled at the assistant to go up in power and direct the light in a slightly different place.

The confidence was overwhelming. These guys knew what they were doing, and everything I had learned was wrong.

I was twenty years younger than the other photographers and also very introverted, so this was the point I stopped talking.

The couple said hi, and explained they had also hired this team for the day. At this point a lot of the pressure was off.

Looking back at that day, I'm reasonably sure the photographers were the ones that closed all the blinds and made the house as dark as possible.

I would find out later they were shooting jpg only at f11, and every image was at least five stops under-exposed. I didn't learn that for the next two weeks.

Back in the day, I didn't know what to expect when heading into the wedding ceremony.

I knew that it was a gazebo (a small circular pavilion made of wood and usually painted white) wedding in a park and that there were ten guests plus the couple.

We arrived at the park, and the gazebo was very poorly designed. It's the dumbest gazebo I've ever seen in my life. Barely enough space for the officiant and the couple. Only one entrance and it was on a platform five feet up. There was no way to get close to the couple's eye line.

I had to battle for a position at the end of the aisle. Three photographers and three assistants. They were still running full flash outside.

I felt so uncomfortable at the end of the aisle. There were five crew and ten guests.

I got a few photos of the couple coming down the aisle, and then once they were in the dumb gazebo, I just sat back and tried to get anything with my 18-200mm super zoom.

There was another problem, though.

The other two photographers and lighting assistants were climbing the sides of the gazebo to get photos. A gazebo that comfortably fit 2.5 people now had an additional four hanging off the railing around them. They were all within two feet of the couple for the entire ceremony with their 11-16mm lenses.

They all stacked at the top of the tiny stairs for the rings and kiss, blocking me from getting anything. I took a few photos to show the couple if they asked why I didn't have any from the ceremony.

I did figure these guys were pros from the level of confidence they had.

The guests talked after the ceremony about how crazy the photography team was. I did everything I could to separate myself from them.

The couple knew I was doing this for free to build my portfolio, so they asked if I wanted a few photos of them without the other team. By this point in the day, the couple also wanted as much space from that team as possible.

We walked around for fifteen minutes, and I got a few photos that remained in my portfolio for years to come.

I learned much about what I didn't want to do that day, which was important.

I sent them about seventy-five pictures from the day fully retouched, and they loved them.

Then about a week later, the worst happened.

They had received the images from the other team, and they were beyond disappointed.

Unedited JPGs at high iso from one of the first digital SLRs ever made.

The couple sent a few sample images of what they received and asked if there was any way I could fix them in photoshop.
They were all terrible images. With all honesty, they might have been the worst wedding images ever taken.
I said I'd do what I could to try and save a few of the underexposed family photos for free, and I did an okay job. Copying people from other pictures that they're better exposed in, painting in some dress detail. They were happy and asked me to fix seventy more. I quoted them $30 per hour and never heard from them again.

So the takeaways here:
- Don't shoot a wedding with a Tokina 11-16 as a primary lens.
- It's important to learn what you don't want to do, just as much as it is important to understand what you want to do.
- Confidence does not dictate the quality of work.

- Have a clear contract, even if it's a free job that says you'll be the main and only photographer.
- Accept that you'll be a button pusher for the first few weddings and no one will see your value until after.
- In the beginning, the value in building your portfolio is worth not making full payment on each wedding.
- It's tough to go from free to $30 an hour.

2

Why Wedding Photography?

You're already into chapter two of a book on wedding photography. So, I probably don't have to do too much convincing.

To put it simply, wedding photography has changed my life.

You're creating something of incredible value for your couples and their families for generations. Plus, you get paid well to do it.

Yes, you have to work Saturdays, but Sunday - Friday is pretty customizable. There will be work, but you can put that work around the family or travel you want to be doing.

Speaking of travel, it was a big reason I wanted to start my own business. I had this dream of working in coffee shops in California or Tokyo. A goal of getting paid to travel and see the world.

I had these thoughts before I even found wedding photography.

When I discovered wedding photography, I kind of did some quick math. If I make $4000 per wedding and can photograph forty weddings annually, I'm making $160,000. Sure, there are expenses, but for the most part the business is pretty profit heavy.

While weddings are, and always will be, the staple of my business, the longer you do them, the more you can explore other options while knowing that you'll at least be able to pay your mortgage.

Creatively weddings are also really rewarding. You can put as much or as little into your creativity on a wedding day as you'd like. I would say that I'm pretty reserved from a creative standpoint, but where I'm reserved someone like my friend Sam Hurd thrives. If Sam's not doing something new and unique within a dull space, he's not having fun. That works well for him and his brand, while it's not that important for me.

I'm very happy photographing the same venues every weekend. Which, to you, might sound great or like a complete nightmare.
I like the efficiency side of weddings. Being able to do a great photo session with a couple, the family, and the wedding party, with a focus on taking as little time away from their day as possible. After all, the photoshoot is not the reason for the wedding.

The other huge plus is that you can tailor your entire business around what you enjoy doing. for example, I primarily do candid photography at weddings, so I just put that in my marketing and it naturally attracts people that like that style.

Enjoy doing prints and albums? Make them part of all your packages. Hate doing them? Don't!

Only want to work May, June, September, and October and take July and August off? You can do that too.

You get to customize this business to be precisely what makes you happy. In the beginning, you're going to take some jobs you know you shouldn't because they're paychecks.

But, with time, you get to limit those and only work with the people you want to.

For me, weddings unlock time, financial freedom, and come with many unique and exciting opportunities. You're also creating something of great value with the skills you've learned over the years.

I am so happy I went down the path of wedding photography, and I can't imagine my life without this career choice.

3

Social Status

Social status is a weird topic to put up front. However, I think it's one of the most important business and life topics to understand - or at least be aware of. Some level of understanding here will give you an easy base to create a sustainable business and keep yourself sane.

Like it or not, most transactions in life are based on social status.

We all have underlying desires that are less than reasonable. Why do we want that Porsche? Or that handbag?

When hiring a wedding photographer, couples are looking for someone who will give them more social status.

Conversely, couples don't want to hire someone that takes away social status. Their status goes down if they're having a black-tie wedding and

their photographer shows up in crocs and jeans.

One thing I don't hear about in wedding photography education is how important it is to display that you're someone who will mesh with their day in terms of personality, and professionalism.

The 'good feeling' that couples have about you is that they don't sense any potential embarrassment by hiring you.

This is where the other games begin. Some couples gain status by hiring a button pusher. Someone that they can boss around in front of their friends and family. Some couples gain status by hiring an equal. They respect you and your work as an artist. They want to show you off to their friends. 'Look at this photographer we just hired!'

It's obvious which couple is ideal for an enjoyable business and life.

In the beginning, you will get some of those button-pusher jobs. More than half of my first

season was this style of assignment. It almost made me quit.

These are not your ideal couples. Learning to attract your perfect couple as fast as possible is important to get out of this button-pusher stage.

I put this chapter near the start because everything I talk about in this book will be related to it. Your social status is not just one thing you do. It is everything you do. Both for your business as well as online as a person.

Social status is emotional, it's not quantifiable. So it is important to sell on emotion rather than something quantifiable. I'll explain that more soon.

Historically humans are tribal creatures. There is safety in the tribe. There is more safety in being necessary to the tribe.

Now social status isn't straightforward all the time.
Example:
My friends with the most money drive $5000 pickup trucks from 2014. They could easily afford a Mclaren or whatever they want. But, for

them, there is more social status in not being that person. They would instead belong to the tribe of humans that live a reasonable life, even though they have the means to be extravagant. The same goes for a mom dropping her kid off at school. If she shows up in a Ferrari and everyone else is in minivans, she will not be part of the tribe.

People compete for status within their tribe, and tribes compete for status against rival tribes.

What does this mean for us as wedding photographers?

A few things.

First, the wedding ratchet is real, especially here in North America.

Everyone is trying to have a slightly more extravagant wedding than their last friend to get married. Not by a crazy amount. Just by a bit. There is a balance.

For you, this means that if you get into a group of friends that are getting married and keep getting referred within that. Each wedding will have a little bit more of a budget than the last.

Social status also has weird implications early on in your career. For example, if you have fourteen followers on Instagram, you might notice that your couple doesn't tag you when they post images. If a friend were to click through a tag and see those fourteen followers, that would detract from the couple's social status.

This effect also plays the opposite way. If you're popular, they will want to brag about you. As a result, they'll tag you more and promote you more organically.

The easiest way to get hired for a wedding is to be part of their tribe. If how you show up on social media aligns precisely with what the couple also values, you'll find that you get hired very quickly.

Sure, you have to be good enough. However, being good enough at photography is no longer enough. For example, around my city, one hundred photographers are good enough to shoot the highest-end luxury weddings in our area. Yet, only three or four get considered.

You might like this advice or hate it, but reaching the high-end weddings in your area

requires a bit of a life overhaul to match status with potential couples.

The good news is that you're already on your way to it. You know that the best weddings to photograph are for people who feel like friends you haven't met yet.

Sure, some weddings will be paychecks. Some will be nightmares. Over time, you will start shooting for a higher and higher percentage of your ideal couples.

Attracting those ideal couples is not as easy as adding a line of copy on your website or showing a picture of you wearing designer shoes. It's everything. Everything that goes into your brand and everything that you display to couples in real life and through social media.

All this said you don't have to become someone you're not in order to photograph nice weddings. People will see through you if you're creating a persona and acting it. Unless you're Drake.

Side note here: my friend Anne T. Donahue wrote an excellent magazine piece years ago

that talked about how Drake created this character Drake. Then started playing Drake every day. Over the years, he eventually became Drake. Now his character is authentic. Drake is not the only example of this happening.

Back to the book here: people buy from people they like. People that seem to come from their tribe.

Many people will tell you that you're the average of the five people you spend the most time with. If they're not similar to your ideal clients, maybe it's time to start hanging out with more people that are.

Now, I'm not saying to ditch all your friends and only hang out with people you think will help you get ahead. But there's a pretty easy and natural progression to this.

Again, you might hate to hear this:

Being in the wedding business will take over your life.

It's Not a negative thing, it's an opportunity. Most of my best friendships are a mix of

personal and business. I think spending time in those friendships is a lot more rewarding, to be honest.

Most of my best friends are wedding vendors. My wife Lindsay is a full-time wedding photographer. Friends that aren't in the wedding business run tech companies or do other entrepreneurial activities.

When you're an entrepreneur, you're kind of on an island. So it's very nice to surround yourself with other islands you can visit that understand what you're going through because they're going through it as well.

Surrounding yourself with other wedding vendors of similar calibre is an enjoyable way to live. You can refer each other and make each other additional money. Plus, you get to hang out on wedding days.

One of the things I miss about working an office job is the sense of community. You see the same people and get to spend time with the ones you like best. Similarly, Going into a wedding day at a venue where you know all the staff, the planner, the cake designer, and the florist is a great feeling.

Being well-connected in the industry also looks good. It shows that you're part of a tribe similar to your couple's tribe. Your tribe just does weddings.

If social status aligns, they don't only hire you. They hire your entire team of friends, and you get to work together every weekend.

Now to go a little bit deeper into status. People get their status from different places, and it's tough to market yourself to all of them.
We'll use a bride and groom wedding as an example here.
To overgeneralize and stereotype - maybe the groom is into weightlifting, and he gets his status from that. Or perhaps he's big into basketball or football, and being knowledgeable about those topics is what he's proud of.
Then maybe the bride is more into art and travel. She gets her status from visiting new places and knowing about small cafes in the 9th in Paris.

So how do you appeal to everyone? The simple answer is that you don't.

We're all playing different status games, and it's impossible to compete in all of them.

What's worked for me is thinking about my ideal couple and, more specifically, the key decision-maker in that couple. For example, in a bride and groom wedding, 95% of the time, in my experience, it's the bride making the purchasing decision. So it's more important to appeal to the decision maker without alienating the other partner.

It's also crucial to be in tune with the other partner, who is probably feeling pretty uncomfortable being in this new world of wedding planning when they sit down for that first meeting.

If one of the partners seems a bit cold or removed at the start of the conversation, we are all quick to assume that this partner doesn't like us. What it actually comes down to is that partner is not in their normal preferred social space.

Knowing this is also something to keep in mind on the wedding day. Sometimes you arrive for getting ready coverage and the day starts a bit awkward. The faster you can identify what

status game the group is playing, the faster they will become comfortable with you.

If you're like me you're incredibly socially awkward. One thing I recommend is to ask for Instagram handles on your contract. That way, you can tag them when photos go up and get to know a little bit about them before the wedding day.

Even some of the most minor talking points and questions can break the awkwardness quickly and get the group acting normal and accepting you as part of the tribe for the day.

As part of the tribe, you will create significantly better work. Work more true to the day, and you'll get access to more authentic moments.

4

The First Weddings

Booking my first wedding wasn't easy.

I knew I had the skills needed.
I knew I wanted to be a wedding photographer.
I just felt utterly invisible.

I spent weeks trying to modify my website to be perfect so that if a couple came across my site, they were sure to book.
I optimized my site for SEO (Search Engine Optimization - We'll discuss that more in a future chapter) and tried every strategy I could think of.

I spent a whole year booking no weddings.

In this book, I want to focus on the things I should have done rather than what I did.
Also, just like the first disaster wedding chapter, it's important to figure out what you don't want to do as well. So if something in this book just doesn't seem right to you - don't do it. Instead,

pull the bits and pieces that align with your business mind and implement them. Then, design a business that makes your life and mind happy.

Let's return to the example of my first wedding. At this point, I had ten images in my portfolio of couples I had photographed and a friend's wedding that I had attended as a guest.

Not enough. Especially now.

Looking back, I should have set up as many shoots as possible with friends.
I would have paid my friends to photograph them. Yes, that sounds crazy. They should be paying you, right?

The value is all on your side in the early stages of your business.

If you can build a business one year faster, you can make an extra $100,000 over your career. It's just waiting for you to get there.

A lot of people will tell you to do styled shoots as well.
These are great, but they have a lot of work to set up. You also need to have some level of

industry connections to get them rolling as well. Instead, I would recommend thinking of a few friends who have gotten married recently, and get them back in their wedding clothes for a shoot.

One of my early successes with this was with a couple I knew from photographing bands. They had a wedding pretty young and didn't have money for a great photographer. Their wedding photos were okay, but they wanted to do something more themselves.

So I asked if we could do a shoot around the downtown area. She had a short dress and they both wore converse. At the time, it was what I wanted in my portfolio. Without a shoot like that to show to people and connect with those ideal couples, I never would have them organically.

Over the next few years, this one shoot turned into five or six other similar-looking weddings. People have an idea of what their wedding will look like, and by doing something similar you fit in to their vision a lot easier. In addition, people are willing to overlook that you're new and maybe haven't shot that much.

I realized early on that people feel like they have discovered you. They find you as this underpriced, undervalued photographer, and they quickly become your biggest advocates.

So back to what I would do now. Don't stress about setting up styled shoots unless you already have industry friends you want to work with.

Set up easy walk-around shoots in locations local people would recognize. If possible, get on the grounds of wedding venues and build your portfolio there.

Next, I would attend portfolio-building workshops. Let other people do the hard work like setting up couples, sourcing dresses, and getting location permits. There are many of these around, and the nice thing is that some also involve a bit of travel. By getting early travel wedding content in your portfolio, you will be faster to generate trust with couples.

Now, there's a bit of a trap to this.

Setting up your shoots with friends and working with workshop couples or potential models does

excellent things for your portfolio. What it doesn't do is develop your skillset correctly. Working with awkward strangers is a whole new thing.

For better or worse, like attracts like. So if you're awkward and introverted like I am, you'll probably end up working with many awkward and introverted couples.

It doesn't take long to get your friends comfortable when you're taking pictures of them, maybe after a few beers. But, when you're photographing strangers, it's hard.

It took me a lot of shoots to get comfortable and, more importantly, confident posing with strangers. If you're a member of www.taylorjacksoncourses.com, you have access to my Wedding Photography Posing for Introverts course. It's a full breakdown of my system for getting strangers to become comfortable as fast as possible.

So the faster you can start photographing strangers, the faster you can build that skillset.

Now the question, 'How do I start getting real couples in front of my camera.'

What I did, and recommend, is gifting engagement sessions to couples inquiring about wedding services.

Again, the value is still all on your side. You're building your portfolio and your 'strangers skill set'. So why not give them a 'try before they buy' option?

I offered most of the first couples to inquire a complimentary engagement session. I would limit it to ten edited images for them. Then I would also mention that I get to use the photos on my blog and social media.

Then something surprising happened.

Every couple that accepted the free engagement session ended up booking their wedding with me. Usually, booking it before we even do the engagement session.

Their small yes to take me up on that offer was a big step towards trusting the newer photographer on the scene.

It also showed that I had confidence in my craft and my skills.

I ran this model for anyone who contacted me for my business's first year.

Other weddings started to come in from friend referrals. They saw that I was creating this wedding work and recommended me to friends who didn't have a typical photography budget.

I took two weddings in my first year for less than I should have. I was happy to work, and money wasn't the goal in year one.

Many educators will tell you that if you sell a $600 wedding, you'll get stuck there. Any referrals from that $600 wedding will never pay $2000 or $3000 for a wedding.

I personally didn't find this to be true. When working for less than I knew I was worth, I would come up with reasons for doing it for the client. Then, I let them know they were getting a deal. I even told them during the first meeting not to let anyone know what I charged them for this.

That sentence tells the couple they're getting this secret deal, and they feel extraordinary. They become an advocate of your business for

a few reasons. Number one, on some level, they probably feel like they owe you for doing this deal. Number Two, no surprise, is social status. If you're shooting that $600 wedding, your website has a starting rate of $2200. That couple wants friends to visit your site to see how much they spent. They want to prove their social status to their friends, which helps get traffic in your direction.

The psychology of this entire business is honestly fascinating. We'll get to a lot more of it over the following chapters.

If I can recommend anything at this point in your career, it's to start building the portfolio for the work you want to do. If you start with the pieces of your dream portfolio, the paid gigs will begin filling in the gaps.

5

Selling on Emotion

In my experience, another key to success in the wedding industry is learning to sell on emotion rather than a numbered list of what they get for each dollar.

Going back to the social status chapter, if your clients believe you to at least be their equal, there will be more room in the budget for you.

It's not as common as it seems to lose a booking on price. It's much more common not to get the initial inquiry because you're pricing too low. They will think there's something wrong with you. While I say to sell on emotion, the price tag is part of that emotion.

As an example:
Say you have the same quality of work as someone across your town. You've been photographers for the same amount of time. Shoot on the same equipment. Have similar deliverables in your packages. You start at $2000, and they start at $5000.

Who does a client think is the better photographer?
The $5000 a day photographer.

It might seem like an unreasonable reaction as the work and experience are the same, but it is a very real reaction felt by the client in response to the pricing.

A fundamental principle that has worked well for me is to not let your couples do the math. It brings them out of their emotional headspace and into analytical space.

This principle took me years to figure out. I went to a talk early in my career, and someone said that the package and credit system was the best way to price wedding photography, meaning they sign up for Package A and get a $4000 credit. This credit can go towards a $2100 album, the digital files are $800, parent books are $920, next-day preview images are $350, the second shooter is $1400, and add a photo booth for $1600.

This strategy did not do me well. Typically it's my couple's first marriage and they don't know what they want or need. It's your job as the

expert to guide them. Make your packages and pricing as easy as you can.

If you're interested, I have an entire in-depth pricing course for members over at www.taylorjacksoncourses.com. Or my pricing is public over on my actual weddings website at www.taylorjacksonweddings.com. We'll talk more about private vs. public pricing later in this book.

People don't buy things; they buy feelings. So let's go with Tony Robbins for a second. People don't buy products and services; they buy identities.

So what do people want? Six things:
1. Certainty. Couples don't want to get burned on this deal, feel pain, or be embarrassed by their decision.
2. Variety. They don't want to do the same thing their friend did.
3. Significance. They need to know you're going to make them feel more significant. Special. Unique.
4. Connection and Love. The feeling that you genuinely like them and are excited about working together.

5. Growth. Their life is going to become better because of this decision to hire you.
6. Contribution. They're helping you be a better artist.

If you satisfy all of these needs, you will book work.
There is one of these that stands out above all others, though. Number three, Significance. People will spend a lot of money to feel more significant. That goes for what they spend on a photographer, what they spend on the wedding, and even what they would spend on a car, a bag, or a house.

To go even deeper. If you want to create the most profitable, sought-after business so that couples don't even interview competitors, do more than they could ever imagine for them.

Now, that doesn't mean spending twenty hours designing a birthday cake for each of your couples.

What this means is to learn to deliver value in a scalable way.

How do you do that?

You go over and above what anyone else would do. Pick some:

- Video venue tours allow couples to make a short list of venues and not waste time visiting every single one.
- Build wedding planning guides targeted at your local area that includes all your favourite vendors.
- Create yearly videos with those vendors to discuss local trends and how to have a more enjoyable wedding day.
- Start a weekly podcast where you interview other vendors.
- Start an annual magazine that you can put in all the wedding shops around your town. Make it break even and split the printing cost with everyone in the magazine.
- Hold an in-person wedding planning seminar at a local venue or rent a space on Peerspace.
- Write great blog post articles for each venue you've enjoyed working at.
- Do a behind-the-scenes wedding day video with other vendors. Tell their story and ask for their wedding planning tips.
- Organize big wedding giveaways with other vendors.

- Organize other giveaways for products and services your ideal couples would be interested in.

You can do hundreds of things, depending on what seems the most fun and exciting to you.

If you can create assets of massive value, they're going to position you as the expert. As a result, your status will climb with both couples and vendors in the industry.

Suppose vendors see that you're bringing them work. You're going to be first on their suggested photographer list every time.

Like I said, significance is the biggest of the six human needs. If you can make other vendors feel more significant, you will create a lifelong friendship while making money along the way.

Coming back to selling on emotion. Stay away from numbers when possible. Make packages simple. Guide them along the way. Let them know what most couples do and give them easy examples of what that looks like.

On your website, and hopefully in the promotional video you'll be making soon, be a

human. Discuss why you enjoy doing what you do and phrase it from their perspective.

They want to know you're a safe bet. That you won't embarrass them, and you're going to make them look amazing.

Make it as easy for them to book you for their day as possible.

6

Website

My first website was terrible.

It was half emo bands at concerts and half weddings.
It was a black background, and there was music playing. I probably spent forty hours making that website. Hand coding line by line in Dreamweaver.

Don't do this.

Don't be me.

You're probably getting hit with ads from Squarespace and Wix every day. But, unfortunately, they're not the best for photographers anymore.

I won't be super biased at this, but maybe a little bit biased.
I'm now a part owner of a company called Focal (www.bookfocal.com).

If you visit my website at www.taylorjacksonweddings.com, Focal made it.

There are a few different tiers of websites starting with an easy AI auto-build that you can set up in ten minutes. It'll even write some copy for your about me section that you can modify. Plus, it'll auto-generate packages for you to get started with. More advanced tiers come with a human working with you to build your site.

Focal is the company I wanted to exist in when I was getting started. That's why I'm involved with them now.Not only do you get a website, but you also get an entire backend to manage your business.

For example, you can take bookings and payments. There are sample contracts you can use right now. There are even simple galleries for you to get started with.

The general idea with this is to roll a bunch of your monthly subscriptions as a photographer into one. So you're not paying Squarespace, a gallery host, and a system to take bookings and sign contracts. It's all in one.

So that's the easy answer. Give the Focal auto builder a shot at www.bookfocal.com

The longer answer if you do want to go it alone and want to design everything yourself is here as well.

Looking at my stats, over 80% of people now view my site from a mobile device. So design accordingly.

Most people arriving at your site also jump right to pricing. They want to make sure you're within their budget before exploring further. From there, they usually bounce to the portfolio page, maybe a few blog entries, and an about me page.

There's an entire chapter on this coming up, but video content is also one of the keys to a website.

The first key piece of video content you make should be a promo video. An easy two-minute edit with some behind-the-scenes footage, sample photos, and a bit about your process on a wedding day. The idea of this video is to summarize everything from your entire site in two minutes.

After you have one piece of video content done and you realize that it's effective it's time to make others. Venue tours, vendor spotlights, whatever interests you. The more real and human you can be, the faster people trust you.

For some reason being in front of a camera gives you an instant expert badge, even if you're still newer in the industry.

Another piece of website content that has been effective for me is talking about what I like and what I don't like about wedding days. I do this intentionally to push my non-ideal clients away while becoming more attractive to my ideal couples.

I hate doing a three-hour photo session on a wedding day, and I'm happy to tell my couples that.
My workflow anchors itself on getting them the most beautiful images in the most efficient way possible. I want them to enjoy their wedding and see their guests rather than.spend the entire cocktail hour off with me at a second and third photo location.

Telling couples this on my website has improved my wedding day happiness significantly.

There are no actual rules, but the most important pages on your site probably will be:
- About Me
- Blog
- Portfolio
- Pricing/Contact

The contact page can double as a pricing page if you just list a starting rate. In the next chapter, we'll talk about my experience with full public pricing vs. having it locked down and only listing a starting rate.

Make it very clear what location you're in. Your location should be included in the title tags and headings.

There is a ton to learn about Search Engine Optimization when building your website, and there could be a book twice the size of this on that alone.

If you're going with a Focal site, that's all taken care of for you. If you're building your own, however, I suggest looking up some SEO

videos for the website platform you're using. Some are very customizable, some are not.

For images to display on your website, I have a few suggestions.

1. Show what you want to sell. If you don't have it yet, get out and shoot it.
2. Use images that people can picture themselves in. I like photos of the couple walking away and wider, more environmental shots.
3. Couples only. I like to focus on just images of couples or some solo photos of just a bride.
4. Keep editing styles cohesive. Try to stick to one preset or look.
5. Make sure the images look good on all screens but prioritize mobile. That means vertical photos are usually better.

For the About Me section. If you're a member at www.taylorjacksoncourses.com, you have access to sample About Me scripts in Book More Weddings. There are some sample promo video scripts as well. You can copy those straight out if you want.

If you're not a member, please don't steal other photographers About Me scripts and pass them off as your own. It's a small industry, and it gets awkward when someone emails you to say stop using my About Me script. Take some inspiration, but spend time making it your own.

When it comes to blog posts, this is where a lot of your early search traffic will come from. Design blog post name in a way that couples searching for a photographer will quickly come across. While you could name the post 'Jess and Steve's Wedding,' a better title is 'Mildred Estate Barn Wedding - Jess and Steve.'

Even though it doesn't seem as personal to the couple, it will book your future work.

Write all the copy also with the perspective of search in mind. For example, mention the city and descriptive words that people might be searching for. Write naturally. Google doesn't like it if you keyword spam.

If you're a Focal customer, you'll also have access to an auto blog feature that will do much of this work for you. (Note: this feature will be out about a month after this book is released)

When it comes to the images, also title them for things people would be searching for. For example, make the file name mildred-estate-barn-wedding.jpg for the wide shot of the entire wedding. If you can add alt tags, you can also put more descriptions in there.

To go next level, you can take the images on your website and post them on Pinterest. You're already doing most of the work, and by cross-posting there, you have another chance of being seen by future couples.

One of the other important things is to let Google know that your site exists. Google Search Console is an excellent place to start with this.

Coming over to the contact page. If you are just posting a starting rate, I think it's reasonable to include it on this page rather than making a dedicated page for just one sentence.

The most important part of the contact page is ensuring your contact form works. It might sound ridiculous, but try it on all your computer and phone browsers. Also, try it every time you make a website update of any kind. I've

specifically had bad experiences with Squarespace contact forms over the years. So just make extra sure things are working as they should be.

Once you think you've completed your website, give it to someone else, ask them to use it as though they were a couple, and give you feedback. Watching how they use the site is more important than their verbal feedback. Do this with a few friends or strangers on the street.

Okay, maybe don't do it with strangers on the street. That's a bit weird.

7

Pricing: Public vs. Private Packages.

A year ago to the day of writing this, I flipped my packages from a private starting rate to a fully public. For almost twenty years of my wedding photography business, I had only used a starting rate.
The switch was scary, I thought that no one was going to inquire with me ever again.

I was wrong. Things got better.

I might not recommend it to you just yet, depending on where you're at in your business but
let's weigh the positives of each.

Starting rate only.
Pros:
Generates more inquiries.
May potentially get couples to find the budget once they fall in love with you and your work.

No one will steal your packages and undercut you by $500.

Public pricing.
Pros:
Only qualified leads are inquiring.
People know what they want.
The first contact to deposit received is usually a day or two.

As you can tell, I might suggest a starting rate only if you're just getting started. More inquiries lead to more interaction. You learn more about what couples want and how you can sell your services. Those first few meetings are very important for learning.If you're a member at www.taylorjacksoncourses.com,you can access three real-life meetings I've had with couples.

I've noticed since switching to public pricing that it attracts couples that know what they want. Another bonus I found is that this type of couple doesn't send a lot of emails. Booking is easy and fast. Leading up to the wedding, they're generally great communicators. Overall, it's made me the same amount of money and cut my email down to a quarter of what it usually is during a regular wedding season.

In terms of life happiness, it's been a significant improvement.

Trying to figure out when to make the switch from private to public? Well, that's hard. It might never felt like it's the 'right time.' After a few years in business, my advice is that you will start to notice when your big booking seasons are. For us here in Northern Hemisphere, Canada, late January to early February seems to be the most consistent so I would recommend switching up your pricing around that time. This way, you can run a bit of a split test. Then, if you switch to public pricing and inquiries continue to come in, it will erase the fear that you had.

After a year, I'm pleased I made the switch.

For what to put in your packages, Focal will give you a good starting point if you use them.

I'm a hybrid photo and video shooter, so I went with four packages.

Two photography only and two photo/video packages.

If you're only doing photography, I'd recommend three packages to not overwhelm your couples with options.

Package One will be your most expensive package. It should include everything you offer. The idea is to place it at the top and create a lot of perceived value. When they see the top package is $9000, all of a sudden, the $3000 package below it looks like an incredible deal.

Make sure the prices scale out correctly. The deal should get better the more money they spend.

Package Two should be the package that most couples get. For me, it's an eight-hour day and a digital gallery. You can include albums, engagement sessions or whatever else your ideal couples are interested in. I include an engagement session in my Package Two, but the next chapter will touch on the changes I'm seeing with engagement sessions in more detail. By the time you're reading this, I might drop it and make it an add-on.

Package Three should be a very small package. For me, it's four hours and a gallery. That's all. If you're posting a starting rate on

your website, this will be the rate you start, so make it attractive.

It's important not to make the jump from the starting rate to Package Two an extreme amount. Couples know when they inquire that the price they see is a basic package. If what they actually need is $4000 more, they're going to be upset. But, on the other hand, if you start at $1900, and Package Two is $2900, that makes a lot more sense.

As bookings start to come in, you can remove products or services rather than raise your prices. For example, rather than increasing that $2900 number, you can remove the album it came with, or the complimentary engagement session. That way, you're making more money but also not pricing yourself out of a price point that you know works in your area.

The easiest way to find your starting rate is to just look around town and see what others are charging. The market is already set, and it's much easier to go with the established market than to try and battle against it.

8

Gear

Personally, my equipment is always changing - it's mostly because I review gear on YouTube. You do not need to change camera gear as often as I do.

I was on Nikon DSLRs from 2005 until 2020. Then Canon for a year. Then Sony for a year. Now I use a mix of Canon and Sony. Nikon lagged in the switch to mirrorless, which is why Canon and Sony became my choices, but they have now caught up. So has Fujifilm's autofocus.

The good news is that every brand has good gear and you can shoot a wedding on any brand you choose. Just because you see someone on the internet doing great work with a particular brand doesn't mean that you have to switch to it to also create great work.

Camera bodies are now coming out way too often. If you'd like to know my current product

thoughts, head to my YouTube channel. Just search for TaylorJacksonPhoto on YouTube.

I typically do an updated gear video every six months or when a new and important item is released.

Again, just because that's what I'm using doesn't mean you have to use it. Even looking back to 2017, there were cameras produced then that are still up to the professional standards of today.

What the switch from DSLR to mirrorless has done is make our lives a lot easier. Eye autofocus is so good now that you almost don't even have to try. Just point a camera in the direction of someone and make sure it's composed correctly. The camera will do the rest.

With mirrorless you see the mostly final image on the EVF or LCD screen, which makes life a lot better. In addition, I'm now comfortable shooting in Aperture Priority mode with Auto ISO. Back in the DSLR days, this was not an option I would have considered.

If you've watched any of my older YouTube videos, I talk about shooting in Manual Mode to speed up my editing workflow. The more consistency you have between images, the faster you can edit them. Now, with AI editing, that doesn't matter at all. Small exposure changes in-camera can quickly be corrected with no extra time spent editing.

So camera bodies will constantly be changing, but my lenses stay consistent.

I am a person that prefers prime lenses rather than zoom lenses. A prime lens is a fixed focal length and doesn't zoom. The benefit is that you can work in lower light and create a shallower depth of field. Also, soft out of focus backgrounds look a lot more dreamy and, in my opinion, make your wedding photos look better.

That said, I do use zoom lenses when the time is right, so I will talk about them as well. Since I'm shooting lenses that don't zoom, I have two camera bodies with me. Usually, one with a primary lens and one with a wider lens, just in case.

I use full-frame cameras.

My main lens cycles between an 85mm lens and a 50mm lens. The second camera typically has a 35mm lens, a 24mm lens, or a 20mm lens.

If I have an 85mm lens on my primary camera, typically, I'll have a 35mm lens on my second camera. So if my main lens is a 50mm, my second camera will have a 20mm or 24mm lens.

I set up an easy button on my cameras to go from full-frame into APS-C crop mode. What this does, is allows me to get extra reach from each of these lenses. For example, a 50mm lens in APS-C crop mode is a 75mm field of view.
This crop will come at the expense of megapixels being lost, but I'm okay with that.

For weddings, I find a 24-megapixel camera to be just right for me. I don't need more than that. You can make big prints and crop in when required. I also used a 20-megapixel camera for a season, which was fine. I don't think you need to spend the extra money to get super high-megapixel cameras for weddings.

If you're shooting a 24 or maybe a 33-megapixel camera, APS-C crop mode will likely give you somewhere around fourteen megapixels. So don't shoot in crop mode all day, but to get a bit closer at times, it's excellent.

If you ever get in a pinch, Adobe has a great image upscaling feature that will do a good job of increasing the size of your photos.

When it comes to lens sizes, I never find myself needing much wider than a 35mm lens on my wedding days. I always have a 20mm lens in my bag as a backup, but I only use it for a few photos daily. They're also photos I could make work with the 35mm lens if needed.

90% of my images are from my primary lens, and 10% or less are from my second body. Sometimes my second body is the same camera model as my main body, in which case it's usually the one I've just upgraded from. Keep them the same brand if possible so you can use your lenses on both.

Even if you aren't using two cameras, a wedding photographer must have at least one backup camera. They all don't have to be

top-of-the-line - your second or third backup
camera can just be an old DSLR that you have
hanging around. It won't hurt to bring it with
you, so you may as well!

Wedding days are long, and sometimes strange
things happen to gear. Have backups.
It's critical to bring backup lenses as well.
Typically, I will bring two primes and one zoom
for a wedding day. If the 50mm is going to be
my main lens, I'll also bring a 20mm prime. The
zoom depends on the camera brand.

Sony--well, Tamron-- has a bit of a unicorn. The
Tamron 35-150mm f2-2.8 is a lens that I could
shoot all day at every part of a wedding. But,
sadly, at the time of writing, it only exists for
Sony.

If I'm on Canon or Nikon, I will also bring a
70-200mm f2.8. This lens is my lens for most
wedding ceremonies. I will also use it for
speeches during the reception if the space
requires it.

For speeches, I find myself using an 85mm f1.4
lens and shooting ambient a lot these days. As
long as the quality of light is good, I'm happy to

go up to ISO 8000 on most of the newer cameras.

To talk a little bit about f stops. My favourite lenses are usually f1.4. The smaller the number, the shallower and creamier the out-of-focus background will typically be.

I find that f1.4 gives the best balance of quality, cost, and weight. Weight is a weirdly important one for me. Some brands only want to make f1.8 or f1.2 lenses as a business decision. Leaving the f1.4 option off the table forces you to go to the f1.2. Spending the extra money and being forced to carry around the excess weight of it.
The f1.4 for me is the choice for me when it exists. Whether it's an 85mm lens, 50mm, 35mm or even 24mm.

With zooms, most will start at f2.8. Which is good enough for low light most of the time but doesn't always give me the background separation I want.

My lens choices are all personal preferences. Look at some lens reviews, and see what stands out to you.

For a camera bag, I like to be able to carry everything with me, so I use the Peak Design Everyday Messenger Bag. It's a thirteen-liter bag and fits all that I need. One pocket has my second camera with a wider lens. The middle pocket has a zoom lens, either the Tamron or a 70-200mm f2.8. The third pocket has my flash.

With the switch to mirrorless, a lot of the flash systems have become a bit weird.
I currently use the Godox V1 as a main flash. It seems to work with all of my cameras. I do not use TTL automatic mode and I shoot everything on manual flash powers. I rarely find myself going over one-quarter power on a wedding day with it. The battery will also last for multiple weddings if used in this way.

I have a filter set for my flash that has an orange and green filter. Orange to match my flash colour to incandescent lights, and green matches a bit closer to fluorescent bulbs, though it is never perfect. I also have a small hot shoe flash trigger unit if I need to do off-camera flash work.

If you're interested in learning more about my off-camera flash work, head to www.taylorjacksoncourses.com. There you can

check out my Off Camera Wedding
Photography video set.

I also keep a simple light stand in my car for
off-camera flash. Just one from Amazon.
Whatever flash you're considering, make sure it
works with your camera body.

Other things I bring to a wedding day include
extra batteries and cards.

That's it. Everything fits in my messenger bag
and is light enough to carry around all day.

By not bringing a roller case with the additional
gear I can be a lot more mobile. I'm also less of
a target for theft or someone moving a bag to a
place where I can't find it.

For me, I like to take the most minimal kit I
possibly can. The fewer choices I have for gear,
the more I can stay in the moment.

Again, this is just all that I do. It doesn't have to
be 100% right or wrong for you.

9

Engagement Sessions and Their Decline in My Business

I want to preface this again by mentioning that this is all from my perspective as a business owner and what I see here just outside of Toronto in Canada. I've heard similar feedback from others in the USA, Europe, and Australia.

Something I've noticed personally in my business is fewer engagement sessions every year. I started noticing this around 2018. Up until then, pretty much all of my couples did an engagement session with me. It was in their package, and they thought it was part of the wedding experience.

Since then, I've noticed that more and more of my couples don't want them.

There are probably several reasons for this. But, in no particular order, I see the most common ones as:

- My couples are into travel and usually do a short session wherever they are engaged.
- They use the engagement session as a bargaining chip with a friend offering to shoot their wedding for free. The couple doesn't want them to, so they agree to do the engagement sessions with them.
- They just think they're dumb and weird and fear how uncomfortable they'll be.
- To save a little money to put towards more hours or services.

This trend also might come down to the fact that your ideal couples are probably pretty similar to you. For example, I'm very introverted, and the idea of an engagement session doesn't seem like a lot of fun to me either.

If one partner is into the idea of an engagement session, usually, the other will agree to do one. If the partner leading the conversation says they don't want one, there is never a rebuttal. My engagement session rate is around thirty to forty percent this year, and I don't suspect I'll see a resurgence of them soon.

From my business perspective, yes, they are money. However, I find them to be a bit annoying for my schedule.

We'll discuss this more in the chapter about building your dream business.

To briefly touch on the dream business here, they're a calendar event that requires me to be at a specific place at a particular time. They're also an event that tends to get rescheduled often for weather or family events coming up.

In the early years of my career, I did everything I could to get out and shoot. If a couple said they didn't have a budget for an engagement session, I'd include a local one for free. Now, many years into this business, I'm able to reclaim a bit more of my time.

For years one through five, shoot as much as you can. Then, in years five through twenty, figure out what makes you the happiest and start tailoring your business to it. More on that later in the book.

Engagement sessions are a great way to build your skills as a photographer. They're a great test run for your couples. They see what they

like, and what they don't like. That way, their wedding day goes more to their expectations.

If your communication skills are lacking, like mine are, they're also a great way to get you more comfortable with one another.

A wedding day photo session is simple when compared to an engagement session. It's an exciting day and there is more going on to distract your couples. More friends and family around to make them feel comfortable. Plus, a photo session is just kind of a standard.

Engagement sessions, especially the first few, are difficult and awkward. Just the three of you meeting up in a parking lot to go take pictures.

What I found helped me and my couple get comfortable early on was to pick an activity. Maybe the engagement session starts at a pub, or they do a picnic. Anything to take the pressure off of me.

My ideal engagement session would be something pretty much entirely photojournalistic. But, again, just because that's right for me doesn't mean it has to be right for you.

If I could just document my couples during an experience of some sort, that would be the most comfortable place for me. My dream would be to follow them around on a touristy day in a location that means something to them. Wine tasting, skiing, walking around New York.

Don't let me skew your thoughts just because that is right for me. If you are more into setting up lights on location and long gowns. Do that.

For me, though, this is my typical engagement session:

The session is about an hour long, so we pick one spot to meet. Ideally, somewhere that has a bit of city and a bit of greenery we can use.

If you have a Pinterest mood board with some outfit samples you like, send that to your couple. Usually, the more well-dressed they are, the more professional feeling the images come out.

I ask my couples to bring a change of clothes for halfway through. We either start in something dressy and switch to something more casual or the other way around. There is

no official rule. I ask to see what they've brought at the start so I can plan locations in my mind. If they show up in something that will go great against green space and their second outfit is more 'city,' I want to make sure we start in the right spot.

I will meet my couples in a parking lot or a location a few blocks from the first spot I know I want to shoot.

Walking with them, I will give them a bit of a breakdown of how I do things. My script is usually something like this:

'I'm not going to pose you too heavily. The images will come out great if you're happy, close together, and having a fun time. If you're doing something weird, I'll let you know, but I'm not going to pose every image like you're in a school photo.
If you have ideas, feel free to do them or shout them out. There's no template for an engagement session, and these photos are for you and your family. So whatever you'd like, I'm happy to help create.'

This script does several things. First, it takes a lot of the pressure off of you. It's now a

collaborative effort rather than you telling them what to do. If I take control and pose something in the first few minutes of the shoot, they will look to me to do that for the rest of the session, and the images won't be personal.

Next, my script lets them know there's no pressure to complete a checklist for an engagement session, that a checklist doesn't exist, and that the photos are whatever you want them to be.

There's more about my posing style in the Introverts Guide to Wedding Photography Posing at www.taylorjacksoncourses.com, but I will summarize some things here.

I do my best to keep people moving for the entire session. If we stop for too long, we all get a bit uncomfortable. I take a lot of walking photos, so that's where I usually start.

I find that walking is the easiest way to get couples comfortable quickly. If you ask them to smile and face the camera, no one knows what to do with their hands. But, if they're walking, they seem to know what to do.

Walking photos also give a nice variety of images in a short time. Start with them walking towards you and holding hands. Ask them to put an arm around each other, to Stop and smile towards the camera for the boring photo that their family is going to want, then keep walking.

It's also a big key for me and my introverted couples to avoid big crowds. I do my best to pick locations that will be pretty empty when we are there. This practice relaxes everyone. If we have no choice but to be in a busy downtown, I'm always looking for small spaces to get away from other people. My couples appreciate this and are much more themselves.

My goal with engagement sessions is to get my couples to be themselves as fast as possible. If they want to stop and get ice cream, I want them to feel comfortable saying that.

Another tip is that if you're in a spot where you can leave bags and a change of clothes in the car, do it. Bring valuables with you, but anything that can stay in the vehicle should stay. I get a larger messenger bag to hold things like their keys, wallets or phones, so they're not in their pockets.

If you've ever done a shoot with a bag of clothes you know how much it impacts the flow of a fast-paced shoot. It's a small thing, but it makes everything feel more intentional. I'd rather everything feel more candid and organic.

Switching up clothes halfway through is also a nice break from taking pictures. Park near a bathroom or have your couples change in their car. There are also pop-up tent-style change rooms you can get that you can keep in the trunk of your vehicle.

If it makes sense, you can also do a location change at this time.

For planning the actual locations, I usually ask the couple at the first meeting if they have a spot in mind. If not, I can suggest a few. Some couples want to recreate their first date, while others just want a few great photos of them wherever.

I do many of my sessions in the same handful of locations because I know those spots work for me. I don't mind repeating these locations for strangers, but if the couple was in another

wedding party I make sure I don't use the same spot I did for that couple.

For gear, my preferred lens is usually what my friend Manny Ortiz and I call the introvert lens, an 85mm. Usually f1.4, and I'll shoot it at f1.4 for most of the shoot. I will also have a 35mm lens with me as well on a second camera body. I use full-frame bodies. A 50mm lens is also a great option. I know a lot of photographers that only use a 50mm prime for sessions like this and even sometimes on wedding days. Aesthetically I like the look of the shallow depth of field primes can give me. It is also fine if you prefer a 24-70mm f2.8.

My advice for gear is to bring as little as you're comfortable with. Rolling a bag around with ten other lenses you won't use just slows you down. Changing lenses also slows the shoot down, which is why I use two camera bodies with my primes.

I shoot all in manual mode, though aperture priority is fine. When shooting manual mode, I usually also shoot through my setup process. Sometimes underexposing a scene opens up a new angle or idea you didn't see before.

After the shoot ends I like to give them a timeline. Depending on the time of year, they'll see the photos in less than a week or two. Then I try and deliver three or four days before I said I would.

In the first meeting, if a couple is really nervous about doing photos on the wedding day, I will always suggest an engagement session as a warm-up. That way we have a chance to work together before the wedding day. They'll be more comfortable and confident with both themselves and my work.

If you're someone that likes to travel a lot, engagement sessions are a straightforward way to start building your travel and destination portfolio. During the first meeting with my couples I usually ask if they're travelling anywhere soon. If they are and schedules can align, I will do my best to make a destination engagement session happen. At the beginning of my career I wasn't charging them anything extra. The value and credibility that came with a shoot of that style did enough good for me that I was happy to just have the experience.

To summarize. There is no official outline to what an engagement session has to be. Make

your engagement sessions an experience that
your couple can be themselves in, don't bring
too much gear, and try to have some fun.

10

Proposal Photography

Proposal photography is also an element of wedding photography that shouldn't be neglected. You're there to document a proposal, but one of the partners doesn't know.

These booking requests come in all different shapes and sizes. Sometimes they're relaxed and easy. Sometimes they're very extravagant.

I'll talk about the two I've most commonly seen in my career.

The first is the easiest. You're hired to do a photo session with the couple, and one of the partners plans to propose to the other during the session. This situation is easiest because it's not weird that there's a photographer around them, and it's straightforward to document from your side.

The second is a bit harder. Usually, it's a public location and time that is set to be the spot. So

you, as the photographer, hang out in that spot and try not to look like a photographer waiting for a proposal (which is weird because you need a long lens).

Before iPhones would share GPS tracking, this was a bit of a pain. Couples would run late, and you'd be stressing out as the photographer. So how long do you wait? Are you in the right spot?

Now I recommend just finding a way to do a location share with the partner organizing it. That way you have proper visibility of their location, which is much less stressful.

Some of these proposals have an engagement shoot element as well. Especially when it comes to destination proposals, they get engaged, you give them space, and at some point, they come to say hi. Then you go for a fifteen or twenty minute photo session around the area.

These are high-pressure situations; if you do a good job, these gigs usually turn into wedding bookings.

On an average year, I get one request to do something like this.

11

Elopements and Micro Weddings

An elopement is a smaller wedding, usually consisting of the couple and witnesses. In the past elopements didn't include family, but now that's starting to change. They were once also rooted in some sort of travel – running off to a fantastic place to do something a little more unique than they could at home. This has also begun to shift, with places like where I live, near Toronto, becoming a destination for elopements even though they might not have the nicest scenery.

Here elopements are kind of turning into something else. Micro weddings.

I have an elopements and micro weddings course over at www.taylorjacksoncourses.com that members can access if you're interested. It comes with pricing guides, website templates, and a lot more.

Elopements come with a superpower for getting your business on the right track. That superpower is that they usually happen within a few months of contacting you, whereas a typical wedding might be booking you a year or eighteen months away from the actual event.

They will build your portfolio faster. Elopements and micro weddings also tend to look a lot more interesting. When you have a very small group, you have more options to have the ceremony in the location that you want.

You can get married at the coffee shop or pub where you had your first date. Or you can get on an airplane and drive out to the middle of the Nevada desert.

For you as the photographer, these experiences will attract new clients. Clients that are also interested in these unique and exciting weddings.

If you're fortunate enough to do some travel work early on in your career, you'll also realize what a significant credibility boost your business gets.No longer are you 'just' a local

photographer. Instead, you're a photographer that has now shot in LA, Banff, or Paris.

The runway to attract elopements is also a bit shorter. Styled shoots in non-traditional wedding attire is the easiest way to show this in your portfolio.

Whether it's elopements or complete weddings, it's important to show what you want to sell in your portfolio so that when couples come to your social media or website, they'll feel a connection to you: That you offer what they're looking for. Being able to visually show that, rather than just words, is much more powerful.

The other plus is those elopements also sell full wedding days.

So the good news is they happen closer to now, they're generally unique, more fun to photograph, and they'll book you future full weddings.

The bad news is geography. Do you live in a place where elopements happen often? If so, you can quickly start or even specialize entirely in elopements. Good locations are places

people fly in to get married, destination locations.

My location, sadly, isn't much of a destination. So while there are more elopements now than ever, there are still not that many in my neighbourhood. If you want to start attracting elopements regardless of where you live, create valuable assets to help couples plan their elopements.

We've started an entire sub business here called Elopers and Co. Our friend Jeff Maeck, an officiant, leads this. He takes the incoming leads, puts together a day for the couple, and fills out the team with what they're looking for. Some couples want photos, some want pictures and videos. Some like my work best, and some like my wife Lindsay's.

We have a framework that they can quickly jump into. It takes all the guesswork away from them trying to plan this whole day themselves and passes it to people that have done it before and specialize in it. For example, we do helicopter elopements where we take care of hiring the helicopter and making a package deal for the couple. We do boats, where we arrange hotels as part of the package. Or simple

one-day hikes to a beautiful location. All of these are very easy to market because they're so visual.

Do I recommend starting an entire business just for elopements as we did? No. What I do recommend is to come up with and execute a few ideas for interesting wedding ceremonies then create helpful guides around that. It can be as simple as a long-form blog post that gives some local elopement ideas, showing a few sample images and connecting a couple with the right people to make it happen.

If there are advanced logistics, you can even partner with a planner to help these events come to life. We've found that they're a bit easier to market as a team rather than just a solo photographer.

Elopements and micro weddings are a lot of fun. They also tend to happen on weekdays, so they're not taking away from your wedding availability.

I suggest being open to them and talking about your enjoyment of them on your website.

When read by the right person, those few sentences will make things happen.

Another option is running paid ads to get in touch directly with potential couples on social media. We'll talk a lot more about paid ads throughout this book.

12

First Meetings and How To Get There

So how does the funnel to a first meeting look? It could begin on social media, or a friend might mention your name and share a link. Wherever that client journey starts, there's a good chance they will end up on your website to try to find your starting rate.

The number one goal of your website is to get people to contact you. All of your pages should get one step closer to contacting you.

From the website side, this means giving your ideal couple no red flags. Instead, get them connected to your mindset as a photographer. For example, talk about why candid photography is best if that's what you believe.

Once they've filled out your contact form, your work in booking them will be 80% done.

When you get an email from a new couple, respond right away. Let your couple know that you're available and you'd love to talk more.

I've won many jobs by responding quickly, setting up a meeting that day, and booking the job before other photographers have even responded to the first email.

Members over at www.taylorjacksoncourses.com also have access to my email scripts.

I like to give them two or three options for meeting times that work for me. Make them strange times, so they know that you're busy. Ten past six tonight, eleven thirty am tomorrow, or eight pm the next day. One of those times will work for them. I would resist the urge to have a considerable window of time available.

In-Person vs. Phone vs. FaceTime.

I prefer phone calls. I'm more comfortable on the phone, and my couples are as well. They are precisely as long as they need to be. I used to meet at coffee shops, which made for my most awkward meetings.

First, you had to identify a couple you've never met in public. You can get pretty good at this, or you can have a camera sitting on your table as an indicator. I'm just socially awkward, which was always challenging to start a meeting. Then there's the awkward part where one of them goes up to order, and maybe that's a three-minute process on a good day (15 minutes on a less good day).
Then if they order something that takes time to make it'll be another 10 or 15 minutes before their order arrives.

I've finished several meetings by the time drinks hit the table.
It's good if you're having great conversations and want to spend an hour with your couple. But, unfortunately, I am not great at conversations and find the bonus time difficult.

In coffee shops, so much is just out of your control.

If you have a place to meet, it's better. I would also sometimes meet my couples at their home. However, this idea stresses some couples out, so don't suggest it as the only option.

When it comes to sales, one of the key reasons to meet with a couple in real life would be to show them your physical albums. I'll be talking more about albums in the Albums chapter.

FaceTime or video calls are also good options. Everyone is comfortable enough with online meetings now and technical issues are relatively rare. The only downside is that video calls feel like work to some.

You can prefer any type of meeting, but I enjoy phone calls. They're easy. The couple can be in their car, driving somewhere, or at home. The same goes for me.

Meeting preference has also come with the experience of working with my ideal couples for years. If your perfect couples want to meet in person, I recommend you meet in person. Talking in the same language will lead to faster trust and faster bookings.

When it comes to first meetings, members at www.taylorjacksoncourses.com have access to three of my real recorded first meetings.

While you don't have to follow any specific script for a first meeting, here's my usual:

I'll typically start meetings by talking about how great their venue is if I've shot there before—something to give you some expert status and reaffirm their decision to book there. I'll then ask if they have a rough timeline for the day, even just a ceremony time.

From there, I'll talk about my typical day. Usually, I'll be there for about an hour getting ready and stay until a few songs into dancing.

I then talk through the photography timeline. Next, I'll ask if the couple is thinking about a first look. There's no right or wrong answer to that question. If the couple is on the fence, I will explain that having one allows them to go to cocktail hour faster and spend more time with guests. Otherwise, cocktail hour is usually reserved for photos.

I'll explain that I only need about forty-five minutes for photography. Fifteen minutes with them, fifteen with the wedding party, and fifteen with the family. Fifteen family minutes is good as long as it's a small list of family photos.

It's nice to have a list of family photos from them, so we can keep things efficient and organized. One of the common ways a family

session goes wrong for me is if we have no list and a random aunt or uncle steps in and starts suggesting random family groupings. If we have a list to go from, that rarely happens.

I ask for the list and if they could give a copy to someone that knows who everyone is. This way, no one can run away for a cocktail when they're in the next photo. Having someone there to help out is great, and there's always someone happy to do it.

Next, I'll talk about how I will take them for sunset photos, fifteen minutes out of their day is all we'll need. I usually figure out the exact timing with the venue coordinator on the day. My goal is not to have that session impact any part of the dinner service but also to get them out at the right time. The right time is a variable, though. In some venues you want direct sun, in others it's better to be outside right after that moment.

I explain that I always do the best I can with the variables given to us on the day.

Beyond those photo session parts of the day, the rest of the coverage is candid and flows as the day goes.

At this point, couples usually have questions they wrote down prior to our meeting. The one that I hate the most is when a couple asks me to describe my style. They pulled this from a what-to-ask-your-wedding-photography question list, and the question makes no real sense. They want to hear if you consider yourself light and airy or dark and moody.

I answer the question anyways.

I explain that my style adapts to the day and is primarily candid. I do my best to accentuate what I see while still being true to the day. I'm not going to make a beautiful light and airy room look dark and moody. Or the other way around. I want the photos to bring you back to the wedding day. To remember the in-between moments that passed so quickly on the day.

Or something like that.

I never do a high-pressure or time-sensitive close with my couples at a meeting. I want them to find the correct photographer for them. If it's not me, that's fine.

I close the meeting by leading the conversation towards the next steps. If they decide to go forward, they just need to email me the package they've chosen. I can do the contract online as well as a payment request. It's 50% of the package to secure the date, with the remaining 50% due two weeks before the wedding. That's usually around the time we set the final schedule for photography.

I also told them that the package doesn't need to be locked. If they want to change packages or add or subtract hours, that's fine. We will figure that out on the final payment.

While I know I've left money on the table, that I could easily go for a hard close at the meeting or say that they save the taxes if they book in the next twenty-four hours, I just never felt right doing that.

After the meeting, I'll usually get an email within a few hours, sometimes the next day, saying they'd like to move forward. Before I had my prices listed publicly, the booking delay was more prolonged, three to five days being more typical. Sometimes it was weeks or even months. It was common for me to get an email

three months after a meeting with a couple asking if I was still available.

With public pricing, bookings also often happen without a single meeting. Instead, two or three messages back and forth, and some couples are ready to book.

13

Finding Ideal Couples

Ideal couples will make your life and your business a lot better.

The bad news is if you're in the first years of your business, you're probably working for many of your non-ideal couples.

I wasn't hired as an artist or as Taylor. I was hired as a button pusher and treated like one. I was there to push the buttons for 80% of the jobs I booked in the first three years of my business.

The first few years were tough, I nearly quit the business entirely. My memories of that time period are that every wedding party was incredibly drunk and out of control, the pushing-over-mailboxes-outside-the-venue type. They were not respectful to anyone. The couples were more in control and trying to keep

the day together, but, for the most part, those days were a challenge.

This time was a difficult period of my life as well. I was nineteen or twenty years old, and my couples were twenty-five to thirty. This age gap to a person with average communication skills might have been easy to overcome. However, I felt like they were living in an entirely different world.

After a few drinks they got loud, and many of the groomsmen became bullies against the younger, uncomfortable photographer. So for a lot of those early weddings, I was the enemy. I was the person who was there to remove them from the bar and stand in front of a camera for photos they did not want to be in.

However, while 80% of the weddings were hard, 20% were incredible.

That 20% were weddings for my ideal couples. Most hired me because we had met in the local music scene over the years. Or at the very least had seen my watermark on images of their favourite band.

Those weddings were incredible. We were on the same page regarding the style of photos we wanted from the day and the same overall energy.

They were excited to introduce me to their wedding party, which really made me feel like a guest at the wedding. I was treated like a friend, not an enemy.

Leading up to the wedding the couple was always looking forward to doing an engagement session together if for no other reason than to hang out a little bit before the wedding day. They were energetic and happy to be there and the images came out great.

Engagement sessions would last longer then, and we'd do a collection of weird activities. I'd go grocery shopping with them or go to their family cottage. I was a friend with a camera.

So now the question is how can you attract your ideal couple from the start, and become a friend with a camera as fast as possible.

It is a three-step process.

Step one: Create the work that would appeal to them. Then set up those shoots and start building your portfolio correctly. Eventually that type of work will start coming to you organically through paid bookings.

Step two: Become your ideal client online. Craft your entire public online identity to be similar to your ideal couple. This includes social media, your website, and videos. This isn't a one-day job; this is a job that's going to last your entire career.

Step three: Add some paid ads to accelerate growth. I've made an entire chapter about paid ads. More to come on that.

The sad truth is that being able to take great pictures is simply not enough to run a business. While I do know some world-class photographers that are artistic enough to book work based on their images alone, they are the exception and not the rule. For the rest of us, we must live the online persona that our ideal couples are attracted to.

Your online persona doesn't have to be inauthentic to who you are. Just a little more curated to the couples you want to work with.

More specifically curated to the decision maker. If you've already done a few weddings with ideal clients, you might know who they generally are. If you can think of a few and the commonalities between them, you'll be off to a good start.

Even if you haven't shot any weddings yet, it's time to think about it.

Who would your ideal couple be? Maybe you have some friends that you'd love to work for over and over again. Look at what they post on social media and what they share.

The more you can understand what is happening inside their heads, the easier it will be to connect with them.

What are their likes? More importantly, what are their dislikes? Especially when it comes to weddings. How do you frame their dislikes into problems you can solve?

For me, a big turning point was building a big How To Plan Your Wedding guide. It talked about all the things that I didn't love at weddings, specifically when photo sessions run way too long. That connected with my couples.

Another key point was mentioning that I like when couples have a wedding because they want to get married, and not because they want to have an elaborate photo shoot.

Walking through my process of an efficient family and couple photo session also became something a lot of couples mentioned in their first meetings.

Then the big one —hybrid coverage. A full chapter on this is coming in the book as well.

Photography and video as a small team were a big way to connect with my couples. They typically didn't want a big video team at their wedding, nor did they have the money to pay for it.

Photography to them was always important, and a simple highlight video was an easy add-on. Once a couple visualizes their wedding day with a video, it makes it hard for them to consider another photographer, because they'd now have to hire a video team as well.

In my marketing and meetings, I would talk about a video being the one thing that many

people regretted not getting, echoing a sentiment I'm sure they've heard from other friends that have recently been married.

From there, I started thinking of the other things I don't love on wedding days and positioning that as a selling feature.

At the time, many local photographers were offering full-day coverage starting at the salon in the morning. Opening the gallery with a few hours of coverage was weird before hair and makeup were finalized, so I included that in my guide. It read something like this:

'While most of my photography is always candid, I don't think I must be there from the start of getting ready coverage. So, instead, I arrive an hour before your hair and makeup are to be completed. I start with the detail photos I need and then turn to candids of everyone once hair and makeup are nearly final.'

Pushing against salon coverage also seemed to be attractive to couples. However, they had also likely been at a wedding where the gallery started with one hundred unflattering photos of hair and makeup not done.

When I do getting ready coverage, I usually keep it a little more abstract until makeup and hair are final. This means shallow depth of field shots from behind, maybe focusing on a hairpiece or other tiny detail. While doing that, I'll the stylist to let me know when everything is finished, and we can do a few brush strokes of powder for the photos. This stops me from creeping on the bride for the entire hair and makeup session. It makes them more relaxed, plus the makeup artist always appreciates you giving them their space to work..

Small things like that above can also be mentioned in blog posts and on social media to help connect with couples that appreciate that type of thing.

Most people have had a negative experience with a wedding photographer, or have heard about one. So by disarming potential problems you can show them that you get it.

After a few shoots, you'll probably hear enough stories from the wedding parties to start a pretty decent list of things you wouldn't do.

Within reason, don't be afraid to mention what you don't enjoy doing. Other photographers are

afraid to because they don't want to lose out on a potential sale. What they don't realize is that by being so generic, they're not attracting the sales that should be theirs.

So create portfolio images similar to what your ideal couples will be looking for, figure out what your couples enjoy and don't enjoy, then craft an online presence that affirms their beliefs and bonds you against common enemies.

14

Getting Hired As a Second Shooter

Getting hired as a second photographer seems simple, but it's not. When I was getting started, I emailed every photographer I could find within a reasonable radius of where I lived. I created fifty personalized emails and sent them out one at a time. Only one got back to me with a polite no.

Every single other photographer just deleted the email.

If you try the same, I hope you see better results.

So let's start with why you want to be a second photographer. It's to build experience with a camera in hand on a wedding day. Some lead shooters will even allow you to use the images you take in your portfolio.

It sounds like a dream gig. Get paid, and also build your portfolio in a less pressurized

environment. These jobs are hard to find, though.

If I could offer you any advice, it would be to form relationships with other photographers first. Most photographers will hire seconds first from their friends and people they like. After that, they'll get more adventurous with their selections.

If you're a complete unknown to them, you will be unlikely to get hired. If you get hired, it's not likely to be for a job where you can use the images in your own portfolio.

Today you have a bit of an advantage that I didn't have - Social media. You can now start getting your name a little more known to other photographers before sending them an email. With that bit of warm-up, you'll see better results than a total cold call.

Following local photographers will also give you an idea of the ones you want to be friends with. Reaching out over the off-season will have mixed results. Some photographers won't want to be thinking of the wedding season quite yet and certainly wouldn't have started a schedule.

Other photographers will already have a team in place for the year.

My advice would be to reach out early in the week during the wedding season. Maybe on a Tuesday when the photographer might have an office day. If on social media, you see they're at a five-day commercial shoot, don't reach out that week.

Reaching out during the wedding season will typically have better results than in the winter because busy photographers tend to be bit disorganized (or they are just straight up too busy to be organized). Sometimes they completely forget they need second shooters. Reaching out at this time could result in a job within the next month. On the other hand, if you reach out during the busy months, the photographer might have had a second cancellation, or they just hadn't hired anyone yet.
Whenever you get hired for the first job, consider it a trial run.

There are also no real rules to second shooter arrangements. If you want to offer to shoot for free in exchange for being able to use images in your portfolio, which is something they might

accept, or they might just pay a standard fee. one.

Even if the photographer looks like they know what they're doing and how to run a business, the truth is we're all just making it up as we go.

For the actual wedding day, ask the lead photographer what they wear or what you should wear, and get there early. Try to bring the gear you need, but nothing more. Some photographers will give you clear instructions, and some will just assume you know what you're doing.

A good second photographer typically finds their place or their angle. Limit shooting over the lead photographer's shoulder, especially during family photos. For any group photos, lower your camera, so everyone knows to be looking at the main camera. This might sound dumb, but there's always that one person who will be looking at your camera while the rest look at the lead.

Don't hover, but also don't disappear completely. Instead, find the images that you might like to have if it was your wedding.

As a second, you have the time and the ability to set up some group photos for families at the event. These make the photography coverage more valuable to all the guests.

During cocktail hour, ask some couples if they'd like photos in between candid coverage. Then make a note of any couples in the wedding party, and do the same for them.

Learn to create valuable images that the lead photographer doesn't have time for.If it's a hot day, bring them some water during family photos. Again, it's a small thing that might be enough to get you hired back.

I will also advise that you don't overshoot the day. Shoot what you need, but nothing more. If you're giving the lead photographer 9000 frames from a seven hour day, it's going to be very overwhelming.

That said, don't delete anything in-camera. Deleting in the camera can create a technical problem. I've only seen memory cards fail when images were deleted from them on a wedding day. Of course, the cards are always recoverable, but it's still scary.

Most photographers will download your cards at the end of the night, or if you shoot on their cards or gear, they'll take them home. If you have agreed that you can't use the images, bring a method of getting those files rather than trying to get them at another time. Don't become a task for the photographer.

Other things to be aware of:
Don't add the couple on social media, and start tagging them. This will be seen as shady, and you're trying to appear as the lead to get referrals.

If anyone asks you what your company name is, it is the lead photographer's company name. Have some of their cards to hand out if anyone asks. If someone asks for your Instagram, tell them you're here for the lead photographer's Instagram.

I think adding vendors you meet is okay if you have a nice time with them but ask your lead photographer first. Photographers are weird, and the most random things will not get you hired back.

Beyond all of this, just have a good time and be a nice person to be around. Smile, and represent the company well.

15

Albums

Albums can make you money. I don't sell albums.

Not selling albums is a personal choice that took me years to arrive at.

I give my couples the images and the tools to make their books. I 100% believe in the value of printing and making books, I just don't want to be the one to do it.

I understand that I am leaving money on the table, and you don't have to be like me.

In the first years of my photography business, I sold albums to almost every couple.

I'm going to talk about how I sold them. What worked, what didn't, and why I decided to stop selling them.

Early on, I tried several album companies, eventually settling on Fiano. Shopping for albums online is hard. I was fortunate enough to attend a photography convention, WPPI, early on. I could see all the books the different brands offered, and I made my choice there.

If you are near a larger conference like WPPI or ImagingUSA. It might be worth checking out just to see all the physical products.

With album sales, there is a bit of a startup struggle. Once you print a sample book, it's hard to switch companies. But, after you meet with a couple and show them the album, that is what they expect.
There's also one other annoying part in the early stages of business. Your portfolio is constantly being added to an evolving. When you print a book, that's your book for the year or even two or three years.

The good news is that most companies give you a big discount on a few sample books per year. My recommendation would be to print one including various images from your portfolio and one album of your favourite wedding.

Software like Fundy Designer makes it easy to put together a nice layout. Don't forget to have someone else look it over before you get it printed since there are no changes. Be very cautious of having important details in the middle fold if you're doing a panorama-style lay-flat book.

For terminology, a page is a page, and a spread is the two pages that lay flat together.

In my experience, the more simple the design the better. I tend to do a maximum of five images per spread. I also tell my couples this so they know that they can't have five hundred photos in a thirty-page album.

For what I offer, there are two options to keep it simple. A thirty-page 12x12" book or a thirty-page 10x10" book. I call the 10x10" the parent book and the 12x12" the couple's album.

In my packages, my largest package will include one book for the couple and two parent albums. These all have to have the same design. If they want different designs for everyone, I charge a fee for the redesign, even if it's just a few pages.

For sales, there are a few upsell strategies, but they always felt a little shady to me, to be honest. For example:: a couple gets that thirty-page book. They know additional pages are $150 each. You do a pre-design after the wedding, but make the book sixty pages, then ask them what they'd like to take away. Most couples can get rid of ten pages, but they'll leave the extra twenty. Then you make an extra $3000 on that sale.

I've always hated the idea of my last interaction with a couple being this kind of sneaky trick. I know there are ways to frame it so you're not the villain, but I will never feel comfortable doing this.

I know thousands of photographers that run models like this and do very well. I think in the USA it's generally more accepted. So there is money to be made, but I'm okay with sitting this one out. But, again, you don't have to agree with everything I say.

The idea of a pre-design does have value, though. One of the biggest struggles with selling albums is getting your couple to select images for the book. Things will get done faster if you give them a pretty good starting point.

There's also a camp that just says to send me forty - fifty of your favourite images whenever you're ready to start the album process. They know that over half their couples will never do this, and they'll keep the album money. In the contract, it will say that you have twelve months or two years to send your selects in; otherwise, the album is forfeited.

I was more a part of that camp. I would never enforce a no-album clause even if a couple returned to me eight years after the wedding. I say eight years because it happened. That said, I never followed up on anyone to make their selects.

So the pros:
- Albums are genuinely nice things for couples to have. I love when couples print their photos.
- Albums help beef up your top package to make it more expensive and your perceived value high.
- Albums can make you more money.
- Albums are a very easy way for friends to show other friends their amazing wedding photos in the best way possible, getting you more referrals.

For me, though, there was one big negative. It came down to my life's happiness.

There was one recurring theme in my business. During the last week of October, my wedding calendar was typically slowing down. I was looking forward to November being my more relaxing month. I would usually work hard the first week of November and get all my October galleries out to couples. I like to make sure everyone has their wedding photos before the holidays.

Then it would start. The album orders.

I shoot a lot of weddings, sometimes up to 7seventy per year. Half of those couples got books, and half of these would send me selects in November wanting their books for Christmas.

It was very stressful to sort out fifteen to twenty wedding album designs, plus alternate parent book designs that were late in the season. Plus, ordering twenty albums plus ten parent books is expensive. While I wish I could say I budgeted correctly and kept all of the album funds in a second account, the truth is that I didn't. This part of the year would always set me up for a

financially stressful holiday. I would find myself looking forward to January when bookings and the money return.

Fortunately, holiday cut-off times are pretty good for the actual album designs. So you can usually order up until about the second week of December and still get a book for Christmas.

I took couples' addresses and had the books drop shipped to them, which is a risk because you have no chance for quality control. But there's also no time.

Sure, if I was smart, I could have outsourced all of this and up-charged to cover the cost, but I never played it that well.

I decided a few years ago that rather than raising my prices, I would take albums out of the package.If couples ask, I'd be happy to include an album for a cost. Since doing this about five years ago, I have, on average, two to three couples asking yearly. A much more manageable number for a studio that I am technically the only employee of.

So if you want couples to buy albums, that's great. If they're not for you, that's fine as well.

Your wedding photography business can be whatever you want it to be. Whatever makes you enjoy your business the most is probably the direction for you.

16

Developing a Style

In my first two years as a photographer, I had ten different styles. I wasn't lost, really. I just didn't know what I liked best. I wanted to do it all. By year three, I figured it out.

In the beginning, I think this is fine. If you want to turn this into a career, though, it's time to tighten up your style.

It's nice to know that I can go back into those images from year three, and they still look fine in my portfolio. Sure, fashion has changed, but overall they still fit with what I'm doing today. For wedding photography, this is incredibly important.

We are creating work that needs to be timeless. So that when a couple looks back on their wedding photos fifty or sixty years from now, they don't remember the in-style editing or TikTok trends. I want them to easily be transported back to their memories of the day.

I think that's why great candid work is so important to me.

For style. Here's what you're not told.

You can just pick one and get good at it.

Your style doesn't have to find you, and you certainly don't have to wait for it. What does take some time is figuring out what you like.

A lot of photography is misleading. You see an image you like, but why do you like it? Is it the subject, the pose, the lens, the light, or the editing? In reality it's probably a combination of all of these elements.

I believe when a lot of people think of style, they're thinking of a Lightroom Preset.
PS my presets are available to members at
www.taylorjacksoncourses.com.

Your style is not an editing preset, although that can be an element of it, especially when it comes to the colour palette.

So the good news is, your style can be learned. You can manufacture your style.

The bad news, however, is that you have to figure out what you like and stick with it for a while.

Also, speaking of bad news, if you're looking at a world-class photographer's work and really in love with it, what you're likely seeing is years of working with their ideal couples. The locations, the dresses, the decor, you're looking at a scene you're probably years away from photographing.

This is why workshops and the ability to set up your own shoots are important to be able to showcase the style you want and not be pushed in the direction of your early bookings.

Step one to finding your style is to start collecting inspiration. Figure out what you like, and think about why you like it. Don't emulate one exact person, but rather a collection of small things you like from many photographers. This might sound easy, but it's not. This takes time and effort.

It's also about surrounding yourself with this work on some level, following Instagram

accounts and filling your visual senses with it as often as possible.

Step two is to go deeper and figure out how they all fit together. You've collected all these images and work that you love, now it's time to find the commonalities. See what you're drawn to across all the work you're looking at.

Reverse engineer images and start to understand all the tiny micro-decisions that went into what made that image come out how it did. Take your time with it. Is it the lighting, colours, or locations? Is it the posing or lens selection? There are some things you can control now and others that you cannot.

There are a lot of places within photography that you can go to. You can gravitate towards very artistic images or very photojournalistic ones, poses and studio lighting, or candid shots in a field at sunset.

It's also important to consider whether there's a market for this work.

While you might enjoy only shooting black and white documentary photos all day, are there enough people who would want that coverage

style? If you live in a big city, like London, maybe there is. However, if you live in a smaller rural town in Ohio, that style might not connect with your clients.

Step three: Build an outline for yourself. It might be helpful to think about this as if you had to teach someone else how to create your curated style. You've brought all these photographs together and they make a nice body of work, now how can you contribute?

I would begin with the technical. If you notice lenses repeating, start there. If everything you gravitate towards is shallow depth of field shot at 85mm or longer, that's one of the first pieces. If a number of the images you've selected are up close with wide angles, maybe 35mm or 24mm is the place to start.

Create a list of poses and scenes you can create with couples or on wedding days.

One tip I got from Sam Hurd is that if you take pictures of these inspiration images before going to a shoot, you can review them in your camera easily when previewing other images. Just make sure you format your card first. That way, the inspiration images will be the first ones

you see. You can also do this with your phone, but it's a little more professional to stay looking at your camera.

If you're like me and sometimes can't explain what you want your couple to do, you can always show them. In that case, save some reference images on your phone.

While it might feel like you're copying someone else, it rarely ends up being that similar. Even if the posing is roughly the same, the elements and people differ. Even though you're modelling after the images you like, you'll quickly notice that you're creating something unique. Something that blends all of your likes into one place.

Now I need to address something of a grey area. I've noticed some photographers who look at one photographer's style only and try very hard to be that photographer. Some of these copycats are very successful. The photographer a couple might want to hire can only exist in one place and can only shoot so many weddings, which is where the copycat comes in. While I recommend against this approach, it is worth noting that it can work.

More importantly, you don't have to create a style that is 100% unique to you to succeed. But, if you can fall into a bit of a bucket, it will help you book work. Some couples are looking for a light and airy photographer. If you fit that, there's a good chance you'll be hired.

So don't feel like you have to make one million photos before your style magically finds you. Instead, you can actively create your style by combining the already existing work of others and filtering it through your mind. It's going to come out as something that you enjoy making.

17

Travel and Destination Work

It won't take long for you to be overcome with the desire to do travel and destination wedding work. It's built into the core of the industry, and it's how many define success.

Going back to the chapter on Social Status, destination work is the game that a lot of the industry is playing to be seen as more successful by peers and by couples. Shooting in other places is the easiest way to achieve this goal. I noticed this early on in my career.

I got started in music and concert photography. Both because I enjoyed it and because it helped me hang out with interesting people. Making bands look cool in photos gave them social status and made them want me around.

One of the bands I worked with often was about to record a new record. We all lived just outside of Toronto, but they chose to make the eight-hour drive to record in New York City. The

producer had done a record for a band called At The Drive-In, and they wanted a bit of the sound from their album "In Casino Out. They wanted to play everything off the floor like a live show to capture that energy. For me, as a photographer, this sounded like a dream job.

So we loaded in their green spray-painted mini school bus and drove overnight to Brooklyn.

We slept on the floor of the studio. I'm unsure if the band spent all their money on recording or if better art is created in a struggle. Do you intentionally put yourself in a struggle to make better art?

This trip was the most fun I'd had with a camera. I was there to document, and we all felt this record would be big. It was that feeling you get before you check the lottery numbers. We had the ticket, and it was for sure a winner.

I spent one of the afternoons taking the train into Manhattan and sitting at the observation deck at the top of 30 Rockafeller Plaza from three pm until dark.

I sat up there thinking I couldn't believe that a camera was why I was there. Sure, the band

liked me enough, but I could also create something of real value for them. I think this was one of the big tipping points in my career. Both mentally and as for my business.

When we returned to Canada after the trip, other bands saw my work with them. Suddenly everyone wanted me to shoot their promo photos and come to their concerts. I was not a better photographer than I was the two weeks before, but now I had a lot more social status and credibility. It works in music, and it works in weddings.

The trick is unlocking that first opportunity.

I got very lucky. My first destination request found me. Unfortunately, this is not usually how it works.

What a destination wedding is for most of us in North America is a trip to an island in the sun down south. That said, a destination wedding is technically any wedding you'd have to travel for.

I had become a decent enough wedding photographer in the Toronto area. Maybe four years into my real career at this point. I had done two weddings in Canada on a beach that

looked kind of Carribean-ish. I had these images on my website, which is the only reason I got a Mexico inquiry.

A couple contacted me saying they were having a destination wedding with thirty of their friends and were interested in bringing me along to take the pictures.

They lived locally to me. The big thing I noticed with destination weddings is that couples want to meet in real life before booking. This also may have been because I was so early in my career, and the trust wasn't there yet. We picked a local coffee shop to meet up at.

Everything should have gone wrong here.

Earlier, I had taken some advice that if you're doing a destination wedding, you're out of the studio for three or five days, and you should charge appropriately.

I went in with a package way too high, and surprisingly, they said yes.

Had I realized how much good that single wedding would do for my business, I wouldn't have risked such a highball offer. Knowing what

I know now, I would be 100% willing to do the first at cost.

I got on the airplane with the wedding guests, and it was an ideal couple. They were there to have a fun time and included me in conversations and activities. Before we landed, I had made friends with a few people at the wedding, and the week was set up to be a nice time.

On the wedding day, I discovered some new challenges shooting in cold AC and then entering hot and humid environments. However, after my lenses stopped fogging up, the pictures went well. I returned to my room around ten o'clock pm, backed everything up, made some blog edits, and went to sleep.

Two days after the wedding, we woke up early to do a sunrise beach shoot in their wedding clothes. While the wedding day images were great, these were the portfolio images.

I loved that the couple was so into waking up early to get some great images. To this day, a second shoot is always something I try and get my couples to do. When you can plan the day

around lighting and be at the right location at the right time, it's incredible.

Returning home with this new portfolio, I was taken a lot more seriously by other vendors and couples. As lame as it sounds, I was no longer just a local photographer.

I made a proper SEO focused blog post about that wedding and returned to the same venue three more times over the next few years. Beyond that, couples considering that venue for their wedding would sometimes find me and bring me to the destination wedding venue they decided on.

The other great thing about destination weddings is that destination couples tend to be friends with other destination couples. So if you do a good job, you'll likely get an invite back to the same group again when someone else from the group get's married.

For years destination weddings have been a key part of my business, and I've done over fifty of them.

I was fortunate to get contacted to shoot my first one. But, unfortunately, this isn't the norm.

Typically you're going to have to work for your first destination wedding. If you have friends or friends of friends getting married somewhere interesting, try to make it work for them.

In the scope of the island down south destination weddings, I realized that I can actually save the couple money by going.

If a wedding books a big group, they're usually given a few free flight and hotel credits, usually a photographer, that they use on themselves. The hotel photography packages are usually expensive and challenging. Pricing models are different than up here, as well as photography styles.

Couples that would like nice pictures are usually pretty easily convinced that it makes sense to bring someone they trust.

There have also been a weird number of opportunities to book destination weddings while I've been on vacation. You start talking to someone and find out they're there for a wedding. A few minutes later, the couple comes by to say hi to them. At that point, if you offer to take some wedding pictures or two-day-after pictures, they might say yes.

We've extended the offer a few times, and they either turn into weddings or family session bookings.

Another option is to find local models or couples that are open to doing a photo session and offer to pay themInstagram is usually the best way to find people, or if it's a bigger place, you might be able to get in touch with a modelling agency.

Another approach we've taken is creating content for hotels.
There's a full course on this over at www.taylorjacksoncourses.com.The basics are that you get in touch with a hotel, and they give you a place to stay and money depending on what packages you offer them. They'll help set you up with a couple of portfolios to shoot around the hotel. These are the easiest turn-key way to a great shoot and a great experience. They also tend to upgrade you to the nicest available room and give you bonus extras over your stay.

If you're interested in doing destination work, there are many different ways to go about it. The most important thing to do is to make it a goal to book your first. Once you have one to

show, things get a heck of a lot easier. So do everything you can to book that first one.

Set up shoots with families and with other couples, and even film some of your own promotional content when on location. Finally, maximize your time there to make sure you get to go back for a second destination wedding shortly.

Destinations are fun to do and bring your at-home business even more credibility. For example, when at-home couples know that a couple flew you to their wedding in another place, they are going to trust you even faster.

18

Hybrid Coverage

Hybrid coverage is doing both photography and video at the same time on a wedding day.

I'm not going to focus too much in this book about hybrid coverage, but it's something that transformed my business.

Over 70% of my couples go with a photo and video package, and I know it's why many choose me. I'm not hiring this video coverage out to a subcontractor; I'm doing it all internally. Either with just myself or a second photographer.

My top package also includes a dedicated cinematographer and full ceremony and speech coverage. If I'm being honest, I don't like doing that package. I feel like when I have both a second photographer and a video person on site, I become more of a manager than the actual creator. Not to mention all the variables you need to troubleshoot, the audio presets,

and all the other challenges that come with full photo and video coverage.

So now that I've talked a bit about what I don't like let's talk about what I do like.

Simple highlight films set to music.

When I first started doing videos, I did it for a challenge. I felt bored doing only photography coverage, which started as a thirty-second to one-minute highlight.

At the time, I was limited by technology. For example, you couldn't switch between photo and video modes fast enough. Technology soon caught up though and allowed me to expand into two to three-minute highlight films.

What I noticed very quickly was how excited all of my couples became. They were always happy with their photography, but this took them to a whole new level.

The first year I would surprise my couples with a highlight film. I made it a goal not to take anything away from the photography coverage. The highlights were primarily candid moments in slow motion throughout their wedding day.

Slow motion is key for me.

The first reason slow motion appeals to me is entirely subjective. I just find it aesthetically pleasing. Couples get to see life differently, they get to slow down. Maybe you like regular speed better, and that's fine. I prefer slow motion.

The second reason I love slow motion is that it helps me get the coverage I need for a three-minute film. When you're also the only person in charge of the photography, it's nice to stretch out some of those shots.

I shoot everything at 60p, which is 60 frames per second. Then when I put it on a timeline to edit, setting it to 24p or 24 frames per second. This means that for every second of 60p footage shot, I get two and a half seconds of footage. So a two and a half-minute highlight is only one minute of wedding day footage. It makes highlight videos very achievable.

While it does take time to get good at video, the good news is you already understand lighting, you understand lenses, and you understand the flow of a day. That's a big head start, but it is also important to learn the technique.

I have a few courses about it for members over at www.taylorjacksoncourses.com

Another way to get good at video is to offer to second shoot your friends for free to make video portfolio content. Make sure the couple doesn't have a video team hired first and think of this like your film school. They'll appreciate the video, and you'll make your friend look like a rock star by getting them a free wedding film.

Kind of like business, learning video is a lot about learning what you don't use. During your first few videos, you'll shoot everything. Soon you'll realize that it only makes sense to include two or three shots of reception details and none of the family formals, and at the next shoot, you won't waste your time filming them. Your highlight film game will get tighter in the shoot, which means the editing will get faster.

Typically a highlight film takes about one to two hours for me to edit. Which I think is a very reasonable addition to your workflow.

When I started charging for video coverage, it was a flat $1000 fee. Then, eventually, I raised my price as my quality and confidence grew.

One thing that is still a problem from time to time is the schedule. If you get a four hour wedding day, doing both photography and video is very challenging. In those cases, I usually bring in someone more dedicated to helping out. While it is possible to do highlight and photography coverage as one person on a condensed day, I found I was never happy with the final product.

Half of my couples chose to add highlight films within a few years of starting them. With video, my sales went up, and my wedding numbers climbed as well.
If I had a first meeting with a couple, it was a 90% booking rate. They couldn't shop around at the same price point and get both photography and video.

If you're year one into wedding photography, it's not the time to consider going hybrid. However, once you have your wedding day workflow down, maybe start seeing if it would be a fit. Collecting clips from the weddings you have now will make your future marketing easier.

While it's nice to have some full highlight films to show couples, it's equally important to show

them that you've been to many different weddings. A promo highlight film that includes many different couples is a valuable sales tool.

When it comes to destination weddings, you become even more desirable for them when you start shooting hybrid. Now they just need you. I do recommend bringing a second to help out, though.

The additional benefit of video is that it makes you an even more well-rounded commercial shooter. Pretty much all of my commercial photography jobs became jobs I was doing both photo and video for. Maybe it was a full video production, or maybe it was just some social content. Either way, I could charge more and make the clients happier.

From a personal marketing perspective, learning video is also incredibly powerful. Making your own promotional videos and any kind of social content you need will save you a lot of money.

Having the ability to be self-sufficient in business takes a lot of the stress away. While you can always hire people to help out, you want to be able to do all the key things yourself

if needed. My business would not have gotten to the point it has without doing video. So if it's something you're interested in, I would 100% recommend you continue learning.

19

AI editing

The biggest industry shift I've seen in the past few years is AI image editing.

A lot of people look at AI editing the same way many film photographers looked at digital cameras in the early 2000s; with fear.

I would recommend to be open to it and to the ways it can make your business more efficient.

At the moment of writing, AI editing is barely a year old. It's already advanced to a point where I can process any of my weddings through it and it will get me 95% of the way to a final wedding edit. There are images I still have to fine-tune, but overall it's scary good.

I use Imagen. You can get some free edits if you use my link https://www.imagen-ai.com/?ref=taylorjackson.

There are also several other competitors in the space, AfterShoot being another example. They started with only culling, and they began at the perfect time.

A lot of the industry has moved from DSLRs to mirrorless cameras. Mirrorless is generally an incredible upgrade, however, it does come with one side effect - more images. Mirrorless has made focusing on an image, and photography in general, so easy that many of us are shooting double the number of frames we usually would.

On my normal eight hour day with a DSLR, I would shoot around three thousand photos. My normal eight hour day on mirrorless is closer to 5500 or 6000 photos.

What the AI culling has done is to take me back to that DSLR number. It culls out anything that was out of focus or images with someone blinking. It's also gotten very good.

If you head to my YouTube channel, there will usually be a current video on what I'm using for AI help.

20

Hiring People

You got into this business to take pictures at people's wedding days, but you'll have to hire as your business starts to scale. That might be as simple as subcontracting a second photographer. Or as advanced as hiring a studio manager.

Let's talk about my experiences over the years.

Hiring second photographers has always been part of the job. I tend to hire my friends first, and if they're all booked, I cast the net wider. I've also trained friends to be second photographers even when they'd never held a camera.

Lindsay, now my wife, came to a few weddings to hang out. She was working full time, nine to five, and I was working weekends. If we wanted to hang out on a Saturday, she had to come to work.

At the first wedding, I handed her a camera and 50mm f1.8 prime. After ten hours with the camera in hand, she was pretty good. By wedding three, she was to the point that I'd hire her as a second photographer. By wedding five, she was fine to go do the guys-getting-ready coverage on her own.

The startup curve isn't extreme for weddings. I would much rather hire a less good photographer, knowing that they socially fit into the day and will represent my company well, than a skilled photographer who is a bit of a dice roll on personality. Less good photographers will get better.

Over the years, I've trained seven of my friends to go from their first wedding with zero knowledge to be a great second photographer.

It's fun to work with your friends as well.

For payment, that's for you and your local market to decide. We usually do somewhere from $40-50 per hour for seconds.

The next person to consider hiring is someone to help out with editing. This used to be very

important but is becoming less important now with AI assistance.

I've hired many different editors. For my first editor, I would physically mail them a drive. My second editor was my roommate. Third, fourth and fifth were all companies I'd upload a catalogue to online. Now, I use an editor for my highlight videos and handle most of the image editing myself.

If you're busy and can spend some money to buy back your time. I recommend you do it. Hiring someone to manage the tasks you don't want to free you up to do the things that will generate more money for your business is always a good thing if you can afford it.

Regarding editing, while spending hours in Lightroom completing the product you have already sold, you're not generating any revenue. Those hours spent actively marketing your business will make you more money.It can also free you up to spend more time with your family and friends.

A wedding photography business is a business that you can almost put unlimited time into. Unfortunately, that can become a problem for

your life's happiness. Figure out what you can outsource, and start it early in your business.

Bookkeeping and taxes are other places I hire people. They are not tasks that I enjoy, and I am happy to pay not to have to do them, and, instead, invest those hours back into the things that make me money or make me happy.

Outside of weddings, if you end up with a very active commercial side of your business, it might make sense to hire someone to handle all those tasks. From emails and taking meetings with clients to invoicing and ensuring everything is in order, having someone there to help will make your life a lot happier.

Interns are also something to consider. There are probably some options if you have a local high school, college or university. My wife Lindsay has had high school and university interns work for her business. They have both turned into paying jobs.

21

My Average Wedding Day

I'm now going to walk you through my average wedding day. This includes the gear I normally use for that section of the day and how things are structured.

To give some background, unless something really interesting comes along I only work at six venues at home. I've curated these venues and become a preferred vendor at them all, which took time. We'll talk about becoming a preferred vendor later in this book.

The venues I work at all have a getting-ready space on site, usually a hotel, as well as a ceremony space and a reception space.

For the most part, all of my weddings happen at one location. This is by design. When I was writing my original 'How To Get Married' guide for my local area, I included all of these venues, as well as talked about how I love when weddings happen at one location.

Logistically, wedding days at one location are pretty stress-free. Or as stress-free as a wedding day can be. I like that, my couples like that, it's an idea we match on and another reason why those couples hire me.

These venues also happen to be within a half-hour radius of my home.

I arrive at the venue thirty minutes to one hour early. I want to give enough time if there's surprise traffic or other issues. If the wedding requires a long drive, I usually arrive even earlier. For example, a two hour drive means I'm aiming to be at the venue two hours early.

Once I'm there, I just hang out, I don't want to rush my couples. This is a great time to grab a coffee, do some detail shots, and even fly a drone if they have video.

I ask the couple when they check in to let me know where they're getting ready. They let me know if they already have a location at the hotel. Sometimes I have to text them the morning of. You can also just go to the hotel reception and ask.

Ten to Fifteen minutes before my start time I'll go to the bridal suite. This is usually around when the couple starts wondering where the photographer is. In the case of a bride and groom wedding, I usually start with the bride. If the groom is getting ready off-site, maybe at a family home, I might stop there first. If they're just in a hotel room, I'll say that we can do getting-ready shots at the venue. The exception being that if I have a second photographer I'll send them to cover the groom.

I typically open the gallery with an establishing shot. Not a lot, just one or two. Then I head to the bridal suite.

I arrive and tell them I'm early and that they don't need to rush to do anything. Arrival for me is always about One hour before they're scheduled to do hair and makeup.

When I enter the room, I never just started taking candids of everyone. I leave the camera pointed down and ask about details. Rings, dresses, shoes, that type of thing. I'll find a spot near a window, grab whatever table I can, and start doing some detailed photos. This acts as a nice warm-up with the group. They have some time to warm up to the fact that the

photographer is there. They also know that I'm not going to be photographing them until their hair and makeup is pretty much entirely complete.

This is a nicer way to enter the day.

After details are complete, I'll usually ask the hair or makeup artist to let me know when they're finished. Then I'll come and grab a few final brush photos.

Doing this puts them at ease. No makeup artist wants to be in one hundred photos while working with a bride. If they're a friend, this changes, and I will do more candids along the way.

At this point of the day, I'm usually on either a 35mm lens or a 50mm lens. The benefit of most 35mm lenses is that they give you a really nice close focusing distance. Depending on the lens, you might be able to get close enough to the rings to get an almost macro shot. So I usually crop into APS-C mode in the camera to get the crop I want on the rings.

If you want you can do this crop in post, but I'd rather save myself from doing the work later.

Once details are done, I'll typically switch to a 50mm or 85mm prime, depending on the room size. Big room, 85mm. Small room, 50mm. It allows me to get close to my subject without being in their space. I will also shoot these lenses wide open at f1.4 or f1.8 to make the background disappear into nice out-of-focus bokeh.

While in a perfect world, we would have a perfectly tidy getting-ready room, unfortunately, the reality is that it never happens.

If you're on Sony, a lens like the Tamron 35-150mm f2-2.8 is also a great choice for this part of the day. My only issue with it is that it's pretty big and intimidating when you're new in a room.

Once hair and makeup are done, it's time to get dressed. I usually step out in the hall and tell them to let me in once the bride is ready to be zipped or buttoned, usually by one of the bride's people or a family member.
A 35mm lens works well for full-length shots, but I find most of my favourites at this point in the day come from a 50mm lens.

If the dress has buttons, the getting ready process actually takes a few minutes. I remind whoever does it to smile and be happy rather than intensely focused. We're in no rush.

If it's a zip, I'll have them pause there and look at each other, smile, and look around. Basically, anything I can do to get a few frames from the three second zip-up experience.

After getting ready, I will take a few photos of whoever was present. Just a simple smile, face the camera, then look at each other. Nothing too complex.

At this point, I'll usually head over and meet up with the other side of the wedding. Sometimes I meet them at the ceremony location and sometimes in a room.

I have a full shot list available to members over at www.taylorjacksoncourses.com if you're interested in seeing shot-by-shot what I typically do.

The Grooms side is usually pretty relaxed.

For same-sex weddings, many of my couples choose to get ready together. This honestly

makes it a lot easier. Also, I love the candids from this part of the day.

Before the ceremony, I'll usually do some quick group photos with whatever family is present. I know I'll be doing more family photos later.

Now for the optional part of the day. The first look.

First looks for me happen at about 50% of my weddings. In the first meeting, I let them know that the main reason they might want to do a first look is to relax their nerves or to get through all the photos before the ceremony. After that, I don't push couples in either direction.

For first looks, I will have a longer lens on. Either a 35-150mm or a 70-200mm. I want to do my best to stay out of the way. I'll also usually make my camera as quiet as possible, which means shooting on silent shutter mode.

Typically, for a bride and groom wedding, I'll have the groom standing somewhere facing the opposite direction of the bride. I'll find shade if it's a harsh sun time of day, which it usually is. I'll also ensure that when they turn around

they're not going to turn right into a patch of sun.

Next I'll have the bride walk up and do one of two things. They can either stop a few feet away and have the other turn around, or they can tap them on the shoulder.

If you have another idea, that's fine as well. My advice is to not overcomplicate this part of the day.

I will shoot the approach in front of the groom, with the bride approaching over their shoulder. After that I'll walk over to get the groom's reaction first, then go back to where I began. This way I can get a pretty good story of the moment for the gallery.

At some point after the first look, they'll look over at you and ask 'what now?'

I ask for a few standard smile and face camera photos. Ask them to look at each other for one, then head to a new location.

At this point, I either stay with the lens I was on for the first look or switch to a 50mm.

In some weddings, the first look is just for the couple,=. For other weddings, we will do all the bridal party photos at the same time. It's rare to do all the family photos at this time though, since, usually, some arrive just for the ceremony.

I don't mind leaving the family photos until after the ceremony. This lets you keep some traditional wedding elements, which I think older generations appreciate.

After the first look, we will do what we can for wedding party photos. First looks are usually at a challenging time of day for lighting. If there is open shade, we'll go there.

I will do a fifteen to twenty minute session with the bridal party. This includes all the shots from my list over at the member's site. I'll also do any combinations of bridal party members that make sense. College friends, siblings, etc.

I'll send the bridal party off and finish with another fifteen minutes with the couple.

I like to do the photos with the couple in several different smaller sessions throughout the day,

rather than a thirty or forty-five-minute one-time session.

Those are the nice-to-haves, at least. Unfortunately, sometimes you have to do all the bridal party, couples photos, and family in a fifteen-minute window because things ran long and it's already sunset.

The ideal two or three sessions over the day usually work as follows: first, look, after the ceremony on location, and a short sunset session to catch the best light.

I'm pretty light when it comes to bridal party photos. When I was first getting started, all of my couples wanted twenty or thirty combinations of the bridal party. I'm happy to say that just two or three are usually fine.

When I feel happy, I'll ask my couples if there's anything else they'd like with the bridal party. If they say no, the bridal party heads off to cocktails. They're always happy with how fast you got everything done, and I'm certain it leads to more referrals.

Thirty to forty-five minutes before the ceremony, I like to have the couple back to a bridal suite or

getting-ready room. Guests will start to arrive and I'll head out to do some ceremony details before everyone's there.

If the reception is set up at this time, I usually do a round of photos of all the tables. No matter how finished the room looks, something will always be added between the ceremony and reception, so you'll likely have to reshoot a bit of it.

I focus on details and a few wide shots. I usually leave the head table for later because there's a good chance some ceremony flowers will be added to the table before it's completed.

When guests start to arrive, I go back to a longer lens. 35-150mm or 70-200mm.

Most of the day, I'm starting to shoot from the LCD screen rather than EVF. For candids, I use the fully articulating screen a lot. I'm often standing ninety degrees from the people I'm photographing. I look for the people in the best light, having the best time, and focus on them.

I do pre-ceremony candids, kind of how I do cocktail hour photos. Make a loop of the room, then head off somewhere else for five minutes.

Come back, see what's changed, make another loop, then head off.

I do my best not to attract too much attention and not to make anyone uncomfortable. If I notice someone that's visually a little awkward anytime my camera goes near them, or if they're making repeated eye contact with my camera any time it moves, I usually avoid them at this time.

One of my goals for the wedding day is to get all the guests in at least one photo. If the light is good at the ceremony, I do what I can to collect most of those while I have the chance. If I know cocktails or the reception will be in bad light so I try even harder to capture candids now.

When I see the officiant arrive, I will go say hello and ask if there are any restrictions. I'll see if they want a new headshot for Instagram, as a joke (they'll usually say yes) and walk over to a window tot ake a few frames with them. Long lenses, 50mm or 85mm, all work for this.

If there is a videographer there, talk with them to see their plan for the ceremony. Be nice, and try to work together as best you can.

I focus pretty heavily on the front-row guests, staying off to the side but keeping an eye on them. If anyone looks like they're entering a conversation that will have a laugh or some good emotion, I point my camera in their direction.

While it's important to capture all the guests at some point in the day, the front row is usually immediate family, and they deserve a lot of your attention.

At some point, the music will likely change, or the officiant signals things to begin. Now I'm in full documentary mode and on a 35-150mm or 70-200mm lens.

My ceremonies are rarely in a church--I have maybe one or two church weddings per year at this point-- And is usually fifteen-twenty minutes from start to finish.

The ceremony will begin with the officiant walking down the aisle to say hello. If the couple wants an unplugged wedding, meaning everyone puts their cell phones and cameras away, this is when the announcement will be made.

I do my best to stay out of the family space and not block the view for important family members. I don't have to stand between a mom and her son to get the shot I need.

The music will change and, usually, the groom will come down the aisle first. Maybe with a parent or two, maybe without.

Then the grooms-people will come down the aisle. For suits, I typically do a horizontal mid-length closeup. Dresses, usually a full vertical length. I do my best to isolate any distracting elements in the background or hide them behind people. Fire alarms, extinguishers, that type of thing, this will save you hours in photoshop.

I also try to shoot tighter at this part of the day. I've found that if I go wider, I tend to include people looking around or taking pictures on their phone, which can take you out of the scene. I'll always get one wide shot but focus most of it on the closeups or full vertical lengths, with them filling most of my frame.

Once both sides of the bridal party have come down the aisle, there will usually be a pause and a change of music.

At this point, I get a groom reaction shot, staying on the groom until the bride has entered the aisle. I do a full variety of photos here. Wide shot horizontal, closeups horizontal, full length vertical.

I back up a bit as the bride gets to the end of the aisle. If she's walking down with a family member or friend, usually, there's some sort of handoff. If working on a 70-200mm for the ceremony, I will usually switch to a second camera with a 35mm lens for this.

With everyone still standing, I go down a side aisle to get to the back of the room. I get one wide shot with them all up at the front and everyone still standing.

The guests sit and I walk about halfway up the aisle to get some different frames. I get what seems good there, then shoot the back of the aisle and down one of the sides. I like to get more straight-on reaction shots of one partner, photos of the front row and some of the bridal party. Then I cycle over to the other side, going around the back.

I do my best to not be loud. I have shoes with rubber soles, so even if it's a hardwood environment, I'll be pretty quiet.

Vows, I usually get to the side to get reaction shots of the one that's not talking.

I'll get closeups of anyone that does a reading, and then I'll get a little closer for rings. Maybe three or five rows back.

I tend to want to get the ring exchange closeup, but it never works out how I want it to. For that reason, I also try and get a full-length vertical shot of the exchange. Even though the ring is small in that frame, I think it's a better photo than a closeup of awkward hands.

After rings, three things could happen:they could kiss, there could be a reading, if you're in Canada, or many other countries in the world where this is a common practice, they go to a table and sign the marriage licence.

If you want to know the rundown of the ceremony, I find it's easiest to ask when you're talking to the officiant. The main thing for my usual weddings is when the first kiss comes.

Again, there are a lot of other styles of weddings and way more in-depth ceremonies with lots of elements. If uncertain, ask someone to tell you the key moments. Sometimes the kiss is a surprise and not announced. Sometimes small elements you wouldn't expect are key elements of the ceremony. Someone will always be happy to walk you through it if it's your first ceremony of that style.

After the first kiss, they usually walk back down the aisle together after a short announcement. You can go for the safe shot and stay at the back of the aisle with a 70-200mm lens. Or you can get up close and walk backwards with them with a wider lens like a 35mm. Both look great, there's no right or wrong answer. If you're working with a videographer and they're going to be four feet in front of the couple as they walk back down the aisle, you'll have to go wide.

You can ask them to kiss as they get to the back of the aisle. This always makes a nice photo.

I then pick up my bag and follow the couple. The celebration at this part is great for candids. I recommend always being there for this

moment. There's usually a lot of energy, so if you're on a wider lens, it should be fine to get closer.

Once the after-ceremony celebration starts to wear down, I do my best to get the couple to head over to the family photo spot so they don't get swarmed by guests.

I have a planner or a wedding party member tell family members to follow us for photos. This photo session is usually something the family would have been told about before now, orit also could be in an announcement at the end of the ceremony.I have a list of family photos they'd like and a friend of theirs to help call out names. Of course, I always talk about this in the first meeting.

The family photos usually go pretty quickly. If we didn't do a first look, I'll go from family photos to the wedding party to couples photos. Fifteen minutes with each group, then send them to cocktails.I have a lot of full wedding days on the YouTube channel if you're interested in seeing more.

I will also always mention to the family that if they want photos with any other groups, to flag me down during cocktails or the reception for it.

I'll typically follow the couple into cocktail hour and grab a few candids.

By this time they're usually lighting candles in the reception space. So I will go in and do a proper round of candids. If there are still people in the space, I will usually start with 50mm or 85mm and get closeup details first. Then when people start to leave the room, I'll go wider and get a room shot with no one in it.

Detail photos like this are important for the couple, but they're also important for your business. If you want to get published in magazines and blogs, these are the photos they'll be after. I know they're not the most exciting, but it's what they want.

Once done with reception details, I'll go back to cocktail hour for another few rounds of candids. Same deal as the ceremony candids. Loop of the scene, then go away for five minutes. Rinse and repeat.

Guests will be allowed to enter the reception space, and I'll put a 50mm or 85mm on for their entrances. Ask the wedding MC where they're coming in from if there are multiple doors. Sometimes the entire wedding party will come in through one door with the couple will coming in from somewhere else.

This is when I decide whether I need any flash power. Recently with mirrorless and amazingly high ISO, I've been using flash less often. As long as the quality of light is good, I don't mind going without a flash.

If there are bad pot lights or the light is just a bit of a mess, I will add flash. I start with on-camera flash. If that works, great. If it doesn't work, I will go off-camera flash.
I have my off-camera flash wedding workflow available to members over at www.taylorjacksoncourses.com

I usually find one safe spot to get all the wedding party entrances. It's nice that there's a bit of warm-up for the couple. That way, you get the best angles and light you can.

The couple comes in, I get the same standard safe shot and then get ahead of them to photograph as they get closer to their table.

My couple often will go right into their first dance at this point.If they do, I'll get some photos with the lens I have on, as well as my second camera body with something wider.

After the dance, they'll sit down, and there are usually some opening remarks from the MC and a grace. The 85mm is typically my go-to lens at this point.

I do my best to stay out of the way of guests, so I'm never blocking the podium. If I have to be in front of them, I time it so it's a quick disturbance.

Usually, the first few seconds someone is on a microphone, they make the most audience eye contact, laughing and smiling. However, once they get to read their speech, the eye contact is usually down on the page.

This is the slowest part of the wedding.

Make sure you talk with your couples before the day and have a plate for dinner and a place to

sit. Again, it's something that many couples won't consider if their venue doesn't bring it up.

I personally don't love sitting at tables with guests. As an introverted person, wedding days are challenging. It's nice to have some time to recharge a bit. Wording this to couples is always a bit weird. I usually just say that we prefer a table for just myself and my second photographer somewhere out of the way. It doesn't have to be in the same room, but I'd like to hear if someone gets on the microphone to start a speech. While the wedding planner says they'll warn you about speeches, they have a lot going on and often forget.

We eat our dinner on our phones. Bread first. All the bread.

Typically speeches will be in between courses, but sometimes they stack all at the end. So if it comes up in the first meeting, I suggest in between courses. I also recommend suggesting a reasonable time limit to couples if they think certain family members might go a bit long. Of course, those family members will still exceed the time limit, but at least they won't do a full hour.

I usually set up an off-camera light for the first dances after dinner. On-camera can work too, but off-camera goes a bit more with the vibe. Sometimes I will gel my flash to match the ambient light, sometimes I won't. Gel is a term for any coloured modifiers you're putting on your flash. For example, a CTO Gel or Colour Temperature Orange will match tungsten-style lights. A green one will match some fluorescent bulbs. It's not an exact science and is more about getting close enough.

If I choose not to gel my flash, I use the difference in colours to separate my subjects from the rest of the room. You can experiment with what you like best.

I typically bounce the light off of something white or grey. A ceiling or a wall near the couple. I shoot full manual flash and will be on an 85mm lens. I start close to the light to ensure everything is going as planned, then circle around the dance floor with my light staying in the same spot. Sometimes you get angles that work well that you couldn't have planned beforehand.

Halfway through the first dance, I'll move the light or put it on camera and try for some

different images. If it's still bright in the room, and the quality of light is good, I might just stay ambient. There are many different ways to photograph this part of the day, and all of them have their strengths.

When the party starts, I will change to a wider lens. 35mm if it's a tame party with a few people on the dance floor, 20mm if things are getting crazy right off the start.

On-camera bounce flash is usually the easiest way to document this part of the day if you have a white ceiling. If you have a bounce card in your flash or an attachment, it's also nice to use.

There are a few other events that happen around this time. One is typically a cake cut.

Most of my couples don't announce their cake cut; they just go and do it on their own with me. Often this is the last thing I do at a wedding, and I head out after this.

For the cake cut, I stay on my 20mm lens. The couple will ask you how to cut a cake. You can ask them if they're saving a tier. Sometimes they forget that the top tier is coming home with

them to be frozen and that they shouldn't cut it.
I then verify that all the tiers are real.
Sometimes there's a styrofoam tier to make the
cake bigger. Usually, they choose to cut the
bottom of the second tier. If they're the type of
couple that would enjoy this, you can tell them
to cut out a small piece and feed it to each
other. Some couples prefer just to make one
slice and call it done.

After this, they go back to the dance floor.

If I'm still around, there is usually a bouquet
toss at some point. I photograph this also with
the 20mm f1.8. I'll typically be in front of the
bride to get a few photos while they warm up
and pretend to throw. Then, when they throw, I'll
get a little closer to the group that's catching it.

There are usually some really nice moments in
here.

Garter toss I'm seeing less and less, and I'm
fine if that one goes away forever. That's also a
20mm lens job if it happens, though.

A few more things can happen at this point.
There might be a sparkler send-off or last
dance.

For sparkler activities, I usually use a 50 or 85-mm lens. Everyone has to spread out a little bit, so they don't light each other on fire, and the telephoto compression makes everyone look a little closer together.

For sparklers, usually, the couple has a pretty good idea of what they want to do. There's probably a sample photo they'll show you as well.The easiest way to do it is to get everyone in a group and the couple in the middle. Have them kiss or do a twenty-second first dance.

The other common one is the sparkler tunnel. You get everyone to line up in two straight lines facing each other, point the sparklers at each other like a roof, and the couple runs through the tunnel. Again, 85mm lenses seem to work the best for me on these. They'll usually run at me for a few photos, then I'll get them to run back around and do it again.

You can also get into light painting, tripoding your camera and having your couple write their initials or draw a heart. Watch a video on that one, and try it before the wedding if you know this will be a request. It's not that challenging to figure out, but better if you generally know how

to do it going into the day rather than watching a YouTube video on-site.

The only thing I will do in the evening is a quick night session.

Usually, I will use some of the dancing as a downtime to go around the venue and find some interesting compositions. Sometimes I'll prelight it using my second photographer. That way, the couple just has to walk into the photo, and there's no guesswork.

LED light panels are great for this part of the day because you can see what you're doing.

If you're in a space with stars, you can also include your couple in a nice nighttime star scene. These are some of my favourites. I set everything up exactly as I want it to be before I get the couple. Then I place them in the scene and take the photo. For star scenes it's usually a long exposure, so I just have them stand still in a comfortable position for ten seconds. Of course, you can also light them and blend exposures in post if you want, but I find it easier to get everything in camera if you can.

Night photos are a great excuse to get creative. They're a lot of fun and something unique for your portfolio.

After this, I will typically download my second photographer's cards before leaving. Or, if it's a friend that I see every week, I might take one of the cards. I have them shoot two cards as backup, and they hold onto one.

I'm on my way home by eleven o'clock, usually closer to ten o'clock.

Next, we'll talk about the backup process once I arrive home.

22

Backup Process

In wedding photography, your backup process has to border on extreme. However, you should already know to bring backup cameras and lenses to wedding days. This chapter is going to focus on what I do for image backup.

First, I think it's important to shoot a main camera with two card slots. Make them full backup duplicate slots. I know, we spent years just using one card slot and very few of us had issues, But There's no reason to take the unnecessary risk now that most cameras have two card slots.

I never take my cards out on a wedding day. I will shoot 128GB cards or 256GB cards in both slots. In the rare case that I shoot way too much and my cards are filling up, I will use my second camera body.

The one exception to this rule is if I'm leaving a venue in a sketchy area or there's a walk to the

car. In that case, at the end of the night, I will take the second card out of my camera and put it in a different location. Maybe this is a decent practice to do even in places you feel safe. Everyone has been watching you all day with a bunch of expensive camera gear, and now you're heading to the parking lot at eleven o'clock at night with it.

I never leave cameras unattended on wedding days. Especially my main camera with the key family photos. I keep that in my hands all day.

It's also important to never delete any images off of cards in the camera. It creates gaps in the card memory, and it's the only time I've ever had issues with memory cards.

Once I arrive home, my backup process begins.

I shoot RAW+JPG in my cameras, so I'm able to very quickly make a backup after the wedding. Within an hour, I will have JPGs backed up online. You can use a service like Dropbox or BackBlaze for this. I like to shoot JPGs so I can easily back up my entire career of weddings on a service like Dropbox without it being too much data.

You can also downsize your raw files with a service like Rawsie or Adobe DNG Converter for web storage.

Step one is to load everything from the day onto two separate hard drives. I don't use a fancy RAID system or anything. Just two hard drives.

One drive is my working drive, and one is a backup drive.

I will set up a folder for each photographer there.

I put my card into the card reader and drag the folders from my card to each drive individually. I don't let Lightroom or any other program do the ingest for me. I like to see it being done.

I also will never drag a folder from one drive to the other. It's always from the card.

Cards are fast these days, so I will sit at the computer while it copies over. I've had a few random issues on Mac where it will randomly restart the finder and close your transfer without issuing any sort of error message.

Repeat the download for each card. Once everything is done copying over, I'll upload all of the JPGs to Dropbox.

If you also want to back up your RAW files online, something like BackBlaze might be the way to go.

I personally don't back up all my raw files off-site.

When a drive gets to about 85% full, it gets retired, and I buy a new one. If you have a desktop setup, Seagate Expansion drives are good. They're what I use. You can also get a lot of additional speed by using solid-state drives as working drives.

My wife Lindsay has an additional step of backup. She won't format the cards until the wedding has been delivered. This means she owns a lot of cards. They're all individually labelled, and she has a spreadsheet that records what numbers are which weddings. Once the final files are delivered to the client, the cards go back into use.

I will also cull the images on the night of the wedding or the next morning. This is another

visual that everything is there, and no parts of the day are missing. Currently, I'm using Imagen to help me with culling and image editing. It's very good.

Making your image selects the night of the wedding or the day after speeds up the workflow. You know what is there, and you're faster to finish it.

Once the final images are delivered to the client, I will leave that gallery online for as long as possible. I promise them five years but have no plans to ever take them down.

One recommendation for portfolio shots is to keep a backup folder of all the raw files on Dropbox.
If your editing style changes over time, it's nice to have easy access to the raws.

You don't have to follow what I do, but please ensure you're backing up your files correctly. You will get emails from couples ten years from now saying they lost their wedding images and wondering if you still have backups. It's nice to send them the gallery within a few minutes of their email.

23

Marketing

Now, let's get into marketing.

I've done many different things for my business over the years. I will outline the strategies that have worked the best over the next few chapters.

My path to booking a lot of weddings was the path to becoming an expert in weddings in the local area. I made an effort to completely immerse myself in the local wedding culture. This is hard at first, especially if you don't have friends in the wedding industry.

I would go to every in-person event that I could. Eventually, I even started arranging photographers' get-togethers in our local area.

Through these get-togethers, I connected to most of the local vendors and venues. Then I

remembered what I had learned in music photography. That people like you more if you make them look cool. So I started doing vendor spotlights and shoots with them.

These shoots were fun. I got to hang out with friends and get better at photography.

Quickly I realized that I was the number one referral on their list. If a wedding couple didn't have a photographer, they'd recommend me.

This also extended outside of real weddings. That if they needed some product shot or wanted to produce a styled shoot. I was the one that they would message. Just like concert photography, it was nice to feel needed and included.

These relationships also made wedding days a lot more fun. I was going into a day, but I knew most of the staff. The additional plus is that I knew who to send images to, and they promoted the images and my photography through their channels.

Many of these vendors were advertisers in magazines, meaning their work was more likely to be featured in print and on blogs.

I started getting a number of 'As Seen On' badges on my website and looking a lot more credible.

The other thing I learned from music is that travel jobs generate credibility. I was travelling a bit for a part-time job, and I started doing some photos along the way. I would do my best to set up shoots with couples in the area I was travelling to. On some trips, I'd even check a bag with a wedding dress for a model shoot.

I really did everything I could to build an interesting portfolio. Other local photographers did have some destination weddings in their portfolios, but nothing like this.

In all honesty, I was a new photographer, and the photos were pretty average. Definitely not better than my work at home. The only difference was that they were taken to other places. Couples seemed to be impressed by this.

I started to book more weddings, and those couples were regularly my ideal client. They also liked to travel and it wasn't uncommon to meet up in New York City for their engagement

session rather than doing it in Toronto. Within a few years, wedding photography had created a pretty fun life.

Overall, the most successful marketing I did in the early days was to be busy and keep working in cool locations. This is something that stays true to this day. I'm always interested in doing work in other places in the world. It continues to reflect positively on my business.

Next, we'll talk about the first big thing I did for marketing. My first promo video.

24

Promo Videos

I was incredibly nervous about making my first promo video. I had been in front of a camera on a skateboard but never had to talk to the camera, and certainly not in any sort of business language.

My friend Mark borrowed a video camera from his job at Blackberry, and we went out to record.

I had printed a two-minute script in big text on a few pieces of paper. I spent the morning memorizing it. We set the camera on a tripod, and it was time to say words.

I went to say the first line and quickly realized I had forgotten everything I'd memorized.

After a few awkward attempts, we realized it would be better if I just went line for line.

I would pick the paper up, memorize the sentence, put the paper down, and say the line

to the camera. It would take me four or five times to get the line to sound natural.

It took a while to get through the simple two minute script, but we got there.

I knew we would be capturing some b-roll to cover the edits.

The next day I set up a shoot with two of my friends that were a couple. The idea was to just go do an engagement shoot, and Mark would grab some behind-the-scenes for the promo video.

There's a lot of pressure when you're filming a behind-the-scenes video. I knew this shoot, and these photos, would have to stand up for years in this video. Fortunately, the light came together perfectly and the shoot went great.

After this shoot, my first promo video was two thirds done. The next and final piece was a behind-the-scenes wedding shoot.

I drove into Toronto to meet with another wedding photographer and her husband. They had been married a few months before and agreed to let me take some pictures of them in

wedding clothes. As we got to the location, it started to rain. Not really ideal.

We did what we could, but the entire shoot ended up being about twenty minutes before it became a total downpour. We got enough clips to cover the edits in the video, but it was by no means one of my best shoots.

We figured we would do what we could with the footage we captured and then just layer in other portfolio images if needed.

The final video came together really well. It looked incredibly professional. We were both very happy with it.

That video was used on my website for almost seven years and was viewed almost half a million times. It was another key to getting expert status and credibility with my couples quickly.

If you're a member at www.taylorjacksoncourses.com, you have access to some sample promo video scripts. They're in this year's edition of Book More Weddings.

I know you've already thought about making a promo video, and I want to give you another push to do it. You probably already have the camera you need. It's also nice to have a lav mic, I use a Tascam DR-10L or the DJI Wireless Kit but there are lots of options out there.

I use Adobe Premiere Pro for editing, but if you want something free, check out Davinci Resolve. iMovie can also work if you want something really simple.

For technical, I recommend shooting in 4K so you can also make a shorter vertical version of your promo video for the social media platforms which prefer that aspect ratio.

Not only is a promo video a great sales tool, but it's a first step to getting more comfortable in front of a camera.

Get comfortable enough in front of a camera to do more content like venue reviews and wedding planning guides. You're going to become the most helpful and knowledgeable photographer in your area and end up booking more weddings than you can ever imagine.

The first step to building a promo video doesn't even include writing a script. Instead, I would just begin making an effort at every wedding or engagement shoot you do to capture a bit of behind-the-scenes footage and keeping it all in a folder on your computer. It can be easy iPhone or GoPro clips, or you could even bring someone to run behind the scenes on the shoots and weddings you're the most excited about.

If you're not working a lot yet, you can do what I did and set up some shoots for behind-the-scenes footage. One of the benefits of this is that the entire video can feel a little more cohesive and polished.

After you have some footage, it's time to decide on a script. I would focus on what you enjoy about wedding photography, speaking in a way to connect with your ideal client. If you say something like 'the best wedding photography is candid,' and your couple nods in agreement, you're that much closer to booking the job.

Now once you have this video. What do you do with it? First, it obviously goes on your website.

Second, it's going to be an incredible video to run as a paid ad, which is our next chapter.

25

Paid Ads on Social Media

I was scared to run paid ads for the longest time. I thought it was me admitting that I was a failure, that I wasn't able to organically scale my business.

After a few weeks of using paid ads, I realized I was wrong.

Paid ads are the gas pedal if you have a solid foundation for a great business. Sure, you'll likely find organic traction over time and might eventually get to the same place of success. However, paid ads will just get you there faster. If you're just running a paid ad of a static link or a single image. You're not using ads as effectively as you could be.

I'm going to talk in the scope of Instagram since it's likely the most common place your couples will be.

Instagram has a preference for vertical video, so it's best to make a vertical video to promote.

While it's a bit annoying to recut a promo video vertical, it is worth the effort. It's mostly just going back through the project, and dragging clips left and right so they fit nicely into the vertical view.

It might also be a good thing to do if you can cut the length down to one minute.

It's also valuable to end it by clicking the link to learn more as a call to action. Again, this can be in text or audio. If you didn't record it with your promo video, you could also do this in voice-over.

There are a few different ways you can promote a video. You can either upload it as a Reel and Boost the Reel. Or you can go into the Meta ad manager and make it a standalone ad.

Whichever way you do it, you will have access to some powerful targetting tools.

On an Instagram boost, you'll be able to target people interested in wedding photography, wedding planning, and other wedding related

topics. You can then make the radius a comfortable distance around where you live. You can also target other major cities nearby if you're interested.

Through Meta ad manager, you can target recently engaged couples. You can also target based on how recently engaged.

I do a full walkthrough of this on the member's site in Book More Weddings 2022 if you're interested in watching the video.

I recommend doing $5 per day for paid ads all year. The catch is that you have to switch up the content every few weeks. To get more advanced, you can split-test different versions of paid ads and see which works the best.

You can also try your luck with different platforms. I've had success with Instagram and Facebook, but Pinterest and TikTok are also good options.

Google Ads are also worth considering. In my local area, there are many photographers using Google Ads to advertise which pushes the price up, so for me personally I don't find them to be a good value. Google Ads also don't do

something that I find important: they don't let you prequalify a lead before they click the link and cost you the real money.

On Instagram, a video view might be worth pennies, while a link click is still maybe 50 cents or a dollar. If someone has watched the video ad and they're clicking through. They're a very qualified lead for that dollar. If someone sees a text link on Google and clicks through, that dollar spent is very unqualified.

This all said, one successful wedding booking from it easily covers the ad spend.

For Instagram and Facebook during January and February, I will put an extra $10 or $15 per day in my ad spend. Here, the end of January to the end of February seems to be the biggest time for bookings. So it's worth the little bit extra. Many couples get engaged over the holidays, and early in the year gets a little crazy.

For ideas of what else to try out for ads, your promo video edit is great, but there are other ways to bring more value to potential couples.

If you were to do a video pointing couples to a guide to the ten best venues in your local area,

it would go over very well. Again, you're offering up your expertise and making their lives better. Doing this the first week of January would also be great timing, as everyone is looking for venues. Any sort of high-value content you can make is encouraged.

You'll notice that content like this gets a lot more clicks. This means in your ad manager, the ad relevance will be higher. This means Meta will actually charge you less for the same ad.

All ads have a lifetime before they burn out, and when that relevance score starts coming down and the per-click cost gets too high, it's time to change to a new ad. Fortunately, there are always new couples getting engaged and planning a wedding, so there is no harm in recycling the ads you've already make.

I find it easiest to batch-process a bunch of them at a time. Spend a day or two making four or five ads that you can cycle for the entire year.

Another easy boost that adds value is carousel posts focused on a venue. Pick a venue you've shot at which is popular in your area. One that you'd like to be a preferred vendor at as well. Do a write-up about the venue. Include some

tips for having a great wedding there, as well as sample images.

Boosting a piece of content like that will do a few things. First, the venue is going to see a lot of interaction. That's going to reflect very well on you. Second, it's possible that in the comments, a proper discussion will start and add even more value to people planning their weddings.

I'd be taking this concept and writing a blog post to permanently be on your site and rank for a search.

If you want to go next level with it, you can also do a video venue review and tour. Being the host of a video like this will show a lot of expert status in the industry, leading to trust from couples. The other benefit is that other competitor venues will also see these videos. They'll want you to do them at their venue, and they might even make it easier to get on the preferred list. More on that in the next chapter.

Paid ads have the ability to rapidly accelerate a well-set-up business. So don't feel like you're failing by paying. Very few businesses succeed on organic alone. Plus, those businesses that

do succeed on organic would be doing even better with paid.

Paid ads are also incredibly powerful around short-term offers. Specifically for family photography.

I would run the same special three to four days before Christmas for years. It was a gift certificate for a family photo session. They could buy it online and print it at their home. I would only make twenty five available yearly, and they would sell out in a few hours.

I promoted them with a simple video saying that if you don't know what to get someone for a gift, get them a photo session.

I usually put about $300 into paid ads to sell this out. To add even more urgency, you could promote it the day before it goes on sale and say the sale starts at ten am. Once they're gone, they're gone.

This is the only time of year I would discount my normal services. I would make the discounted package only include ten images and a twenty minute session. This made it different enough from my regular family sessions.

With paid ads, you can reach everyone in your local area, even if you've never been in contact with them.

This is also a great time to be in their mind as photographers since friends and family might get engaged over the holidays.

Another great way to promote these sales that often gets forgotten about is mailing lists. We'll be talking about them shortly.

26

Becoming a Preferred Vendor

Becoming a preferred vendor is a great way to book weddings.

Some venues will have a long list with many photographers, and some venues will have a shorter list. So while the first step is to get on the list, the big step is becoming number one on that list.
You don't have to be listed first, but in the sales meeting, you want to verbally be the photographer that the venue suggests.

This is a long game, and there aren't really any shortcuts.

To become a preferred vendor, you have to show a few things. First, you're someone that represents the venue well. That you're not going to cause any problems with their clients.

Second, you follow the rules, and they enjoy working with you.

Third, you create great marketing material for them. To most, this means your images.

I said there aren't any shortcuts, but maybe there's one.

If you're helping the venue book work, you'll be fast-tracked to preferred and top suggested.

They can always get nice images of their venues, but very few photographers refer a couple to the venue. It's not as hard as you think, either.

In the last chapter of paid ads, I talked about creating venue carousels and video tours. These are things that promote you but also promote the venue.

Listing the venue in a Top Three Places To Get Married guide will likely have someone contacting them because they saw it. Even if the couple doesn't mention them, the venue will still notice that you're promoting them.

Sustained promotion over a longer period is even better. Every few days, a story or a mention of some sort. Venues are busy and not

always thinking about adding to their preferred list. Usually, once or twice a year, they revisit the conversation. If you've been known for a while and have been actively helping book them couples, you're going to be in high consideration.

When you're in the venue, you can also just ask. Even asking what the process is or what they consider when adding a preferred vendor will start the conversation.

If you haven't shot at a venue, bringing them a turn key-styled shoot is also a nice option. Offer to shoot it at ten am on a Monday or Tuesday when they don't have any other events. Make it as easy as you possibly can on the venue.

If they seem very interested in the styled shoot, bring them into the conversations about what that styled shoot will be. They might connect you with other preferred vendors at the venue. Then slowly, you become part of the venue family.

The more you can work at a venue, the more likely it is to be preferred. The easiest way to book jobs there is to actively promote the venue. Have posts and videos about it that rank

on Google. Do some paid ads promoting yourself and the venue.

If you're promoting a few venues above others, you'll notice that organically you end up booking weddings there a lot more often. Once you're around for a few weddings, it will become very easy for the venue to include you on their list.

For what the list actually means. There's no real standard. It could be on the venue's website, or it could be a handout. They might print a magazine. They might even ask you to pay money to be on the list.

In my experience, no venues ask for kickbacks on bookings or a percentage of weddings you book. I have heard of it happening, but it's rare.

There's also a chance that a venue's list might be closed. That it's only family members or something weird you can't control. I've noticed this at a few venues.

Once you're on the preferred list, this is another badge of credibility. You can advertise on your website that you're a preferred vendor at that venue. You can even offer something special for couples that are getting married there.

Maybe a bonus hour, or free next-day preview images. Something that doesn't cost you a lot.

I do these specials for the venues and anyone coming in through a planner I work with often.

In my experience, you can be a preferred vendor at many venues. So I'd pay special attention to promoting them all somewhat evenly.

Typically there will be one venue you work at the most and have the best relationship with.

In this case, I typically offer them some bonus extras. I've even done free short promo videos for my favourite venues.
Another thing that paid for itself one hundred times over was giving the venue a sample album.

When I had enough images to do a book on just the venue, I printed one and gave it to them.
One thing venues really seem to like is when you can help them promote off-season weddings. Here, it's very difficult for them to sell winter weddings.

If you can put together a few nice spreads in the book to showcase winter, they will appreciate it.

Outside of the book, building blog posts like 'Best Places to Get Married in the Winter in Your City' will also show them that you get it and you're on the same page.

Once a year, I would also offer to shoot the new menu items for the season and update company headshots. Sure, I could have charged a normal rate for these, but the staff were helping me book fifteen to twenty weddings per year. The happier I can keep them, the longer that continues.

Being a preferred vendor makes filling each year a little bit easier. While your business will never be fully on autopilot, this will be pretty consistent in generating bookings for you every year.

27

Email Lists

What is it, 2001? Email Lists are still incredibly effective in my business.

As wedding photographers, we're kind of in this weird space.

We create a business that can generate a very high thousand dollar plus sale. Just one time, though.

After the couple or client buys, they'll never buy that same product again.

This is why it's important to build a mailing list.

While it's true that your couple isn't going to buy another wedding from you, they can still remain a lifelong customer.

Family sessions are the key here.

I know I said this is a book on wedding photography, but it's nice to have a secondary income that supports our main business.

Family sessions aren't something you have to run all year, either. Instead, you can offer them at slower times.

The idea is to turn your one-time wedding clients into someone you see every year.

Social media works okay for this, but you're at the mercy of the algorithm. With a mailing list, you have access to them at any time.

If you have a small client list, you could even send out a personalized email to everyone.

For where to run your email list, Mailchimp is free up to two thousand emails. So that might be an easy place to start.

Depending on where you live in the world, email laws might be a bit different. So even though you're a small list, ensure you abide by the proper rules.

Now the key to getting people to sign up for your email list is offering something they can only get by being on it.

I like one-time offers with an expiration date. For example, 'Sign up to my email list until midnight, and I'll send out 25% off family session coupons!' That type of thing.

This is also a great thing to boost with paid ads as well. Your market is no longer just engaged couples between twenty three and thirty five years old. It's everyone. Well, not everyone, but you get the idea. A much larger market.

For who books the family session, in my experience, it's one of two people.

First-person, past bride booking for family photos about two years after their wedding. Usually, this includes a new member of their family.

The second person is the mother of the bride or groom.

Good news, if you want to target more mothers. A lot of them hang out on Facebook. So paid

ads to target them to get them on your list are very effective.

Again, come up with a hook they would be interested in to sign up.

Now, when you use the list.

Since I only run one or two family session offers per year, I give them a bit of lead-up.

A week before the sale goes live, I'll send out an email saying that on Tuesday at ten am, I will be releasing twenty slots for Christmas family sessions at a 30% discount.

I resist calling them mini sessions personally, but if those are a known thing where you are, it might make sense to call them that.

Also, if you have a Focal website, you can set up a mini-session package. It will include available time slots, take payments, and schedule people. Learn more about that at www.bookfocal.com

If you are discounting services, explain why they are being discounted. For example, maybe this session only comes with 5 full retouched

images, and it's a bit shorter. They're not required to buy additional photos, but they're $x per image or $xx for a full gallery unlock.

If you're into in-person sales and want to sell prints only and not digital, this type of offer can be converted into that as well. Ensure you're transparent about the pricing, so you don't surprise anyone.

I like to send out offers around holidays. Christmas and mothers day are the big ones.

My wife Lindsay runs seasonal sessions that she will do each season. This is because so many of her couples will return for at least two of them yearly.

If you want to make more money, make more offers to an extent.

I typically just run the holiday season special because it's a low point in my income for the year. So it's nice to get that income boost going into the winter.

Other than for specials, I don't use my email list. While it might be good practice to remind people that you exist, I just forget it exists.

Email lists are a great way to generate income when you need to. You have instant access to everyone that's signed up, and they're primarily past clients that know and trust you.

Sign up and get one started today, and keep adding to it while you build your business over the next years.

28

Wedding Magazines

It was always my dream to get into a wedding magazine. Getting into print might be your dream as well.

There's something special about being in a printed book on sale at stores.

Well, I had a pretty rude awakening.

Pretty much all the magazines accessible to younger photographers are all pay-to-play.

This means, if you take out a full-page advertisement, there's usually a real wedding day included.

It's rare that any wedding in a wedding magazine is run if no one attached to the wedding is an advertiser. The good news is that there is a good chance venues and other local vendors are advertisers with different magazines. If you know who those vendors are

connected to, you can usually get a wedding run pretty easily.

Wedding magazines care primarily about the details. So make sure your wedding day details game is strong. Of course, they'll want a photo of the couple, but the details are more important unless the couple is famous.

By details, I mean everything that goes into the day. From the getting-ready robes, to custom glasses that might have been made, to hair pieces, dresses, suits, cufflinks, shoes, flowers, ceremony setup, all parts of the reception tables, food, specialty drinks, gifts for guests. Everything. Most magazines will want about one hundred photos to choose from, and if you give them all the details, they will be happy.

Shooting for the details is also just really good practice. You should be doing it anyways, and if getting in a magazine or on their blog is additional motivation, that's a good thing.

If you want to spend your money and become an advertiser in a magazine, here are my experiences:
I don't think I booked any weddings directly from the advertisement.

For me that was never the value.

The value in being in these magazines was to align myself with other vendors that are also in the magazines. It's very easy to set up a styled shoot if you're shooting something for submission to a magazine that the other vendors are a preferred vendor of.

If you involve the magazine itself in these shoots, there's a good chance they might allow you to photograph the cover.

These are all great boosts of status and credibility for your business.

Having a digital copy of the spread and posting it on your blog is a great way to make the one-time investment that a limited audience saw, and make it into something that many people will see over a long period.

The 'As Seen On' label on your website is a nice trust indicator for potential couples. Seeing other logos just helps people see us as more legitimate.

Some services make it easy for you to submit to many different publications. Two Bright Lights is

the main one that comes to mind. I've had success getting on blogs by submitting through Two Bright Lights, but all my print success has come from what I discussed above.

Now, if you want to go next level. As well as you have the time and interest.

Once you have some vendor relationships in town. One thing I would recommend would be creating your own small magazine. You can find templates online to make it easy.

The idea is not to make money, but to feature the venues and vendors that made your weddings happen. You can also showcase other friends that are photographers if you'd want.

If you're able to design a magazine and do a limited run of them, you'd have enough to get into the shops you've featured in the book. How you finance this is up to you. For example, you could ask vendors to each pitch in a small amount of money to cover printing cost, or you can just cover it all yourself.

The idea here is to make a magazine that these vendors will be giving out to anyone that comes in their store, or meets with them for a wedding.

There's a good chance that no other photographers in your city have done anything like this.

What this means for next year is that other vendors will want to be in it. Maybe you set up some styled shoots for it. Build your portfolio, build your connections, and have a huge expert status credibility indicator in the world that all other local vendors are aware of.

You'll notice a shift happens, where venues and vendors start referring you more because they want to be in the magazine. If you don't work together, there's not a likely chance they'll end up in it.

A magazine is a big project, but the return can also be big. If it seems interesting to you, it might be worth researching.

29

Wedding Shows

Wedding shows are incredibly saturated with photographers. Some limit vendor categories, but most don't. If one hundred photographers and one florist sign up for a wedding show, the show will still run.

I've had mixed results with wedding shows in the past. It's nice that you get to be there in person. If it's another spot that people see you, that's a good thing. It's also a thing to post on social media and your blog that gives you credibility.

The downside is that I rarely see bookings directly because of normal wedding shows. I find them stressful, to be honest.

If I can give any advice, it's to have a way to collect email addresses on site, and follow up with people. Meaning you could give away a wedding or an engagement session. Something

attractive enough to get people to give you their contact information.

I have friends who go all out for wedding shows, and have spent over $10,000 on their booth. They do well. I also have some friends that did very well at shows when they were a low cost wedding photographer. The middle is where it seems the most difficult to be successful at them.

All of this said, most wedding shows are break even if you book one wedding from them. So if you have the time, they might be worth it. Similar to magazines, one of the reasons to do wedding shows is to connect with other vendors in real life. You'll make nice friendships if you're beside a venue or an officiant for the weekend.

Where I've had better success is with preferred vendor wedding shows.

Preferred vendor wedding shows are where a venue asks all the preferred vendors to come out for a more low key show. These are usually in the prime booking season and don't cost anything. You're not expected to create a large booth or anything complex. Just a few albums,

and TV or large monitor, and some giveaways are all you need.

Same rules apply to this show, to make the most of it, figure out a way to collect email addresses.

I also like to create some sort of branded takeaway as well. In the past Lindsay and I have done branded chapsticks. It's winter and dry here in January, and it's an easy thing that people are interested in taking. Then it sits in their purse for the next few months.

Whether it's a public show, or a preferred vendor show, I like to run a special of some sort only for people at the show. $500 off weddings or something like that. I typically don't love discounting, but it seems to get more people contacting me after the show. People will also reference it in email if you make it a handout. Then you have some visibility on where your bookings are coming from.

For public wedding shows, if you're a mid range photographer, they may or may not be worth doing. On the other hand, if you're a low cost photographer, you might see a lot of bookings from them.

There is also another tier of wedding shows. Luxury high end invite only. Sometimes these are attached to high end wedding magazines, and you have to be an advertiser to attend.

The value here is vendor connections as well. You might see some bookings, but you'll always be successful if you go in to generate and maintain connections with other vendors.

It's a long term strategy, and it will make your business bookings for years to come, rather than just that one day.

30

Social Media

Tiktok, Instagram, Facebook, Pinterest and
YouTube.

It's a full time job if you want to run social media
on all platforms simultaneously. So in this
chapter I'm going to talk about which ones I
use, and some ideas to maximize reach.

My suggestion is to pick the ones you enjoy. If
you find it easy to put your images up on
Instagram, then keyword them again for
Pinterest, there's no problem with stopping
there.

Social media can easily consume your life as a
business owner if you let it.

Let's talk about the biggest one for my business
right now.

31

Instagram

Instagram is where the majority of my couples are active now. I find paid ads there to be the most effective. You can easily target people by those that are actively looking at and engaging with wedding planning content.

The good news is that you no longer just have to target the couple. That your net can now include people helping others plan weddings as well. This can include wedding party, and even parents.

There's more in Book More Weddings 2023 over on the member's site at www.taylorjacksoncourses.com.

With a few dollars, you can now be in front of a large audience interested in wedding planning. Very nice trade in my opinion.

For actual Instagram content, and what is performing best. Please don't model exactly

what I'm doing. I run a bit of an unusual business now with YouTube content, education and also weddings.

A lot of the advice you get will be to narrow down and only post wedding content if you want to be a wedding photographer.

I don't entirely agree with this.

While it will book weddings, wedding images don't appeal to everyone. If you've already photographed a couple's wedding, they're still following you. They're probably over wedding images.

I think it's important to strike a balance between content that appeals to your ideal couples and showcasing your photography.

If most of your following is local, I don't see any problem showcasing local content. Other businesses you support, places you go, events and activities worth doing.

You have the skills to showcase things in a way people usually don't see on social media.

The landscape of what works best is always shifting. When writing this, Reels and ten image carousel posts are tied as the best things you can do on the platform.

Reels and carousels are also the best things you can put money into for paid ads.

I'm a big believer in posting helpful and, if possible, entertaining content.

Rather than just posting a few photos from a wedding day with the couples names and hashtagging it. Think about what you learned on that wedding day that could be helpful to couples booking weddings. Write that in the caption.

Make sure you're tagging the venue in the location. Couples scout venues by looking at what's been posted there recently. The goal is to be in the venue images and give valuable information they'll actually read. For example, wedding planning tips, meal suggestions, whatever you think could help couples looking at that venue.

One of the key metrics for Instagram is making content that gets shared. So the more content

is being sent through DM, and shared on stories the more Instagram will show that content.

When creating or posting anything on the platform, think about you can make it more sharable.

If you want to get even more advanced, brainstorm the most sharable things you can create before even thinking about what to post.

I have a notepad document on my phone with ongoing ideas.

Typically I'll schedule some time in a day and create a few Reels at once. Not to be posted back to back, but spaced out. I find it easier if I have the ideas ready to go. Sometimes I'll script them or write a bit of an outline.

Vertical video content is here to stay. It was a bit of a mindset shift for me. Wedding day, and behind the scenes I'm thinking about ways to create this style of content that will be helpful and sharable.

If it's easiest in the beginning, save a few Reels and use them as inspiration for what you want

to do. If you see something that stopped you, and maybe even got you to share it with a friend, think about what that content worked.

Similar to what we talked about earlier when it comes to intentionally building your style, you can also do that on Instagram.

Figure out what you like, and collect a bunch of Reels. See the commonalities between them. Then, start building your style in those commonalities. You'll create something unique to you.

Now I know you might be saying that you got into this wedding photography thing to be a wedding photographer. While it's sad we can't market on great images alone anymore, it's better to go with the market rather than fight against it.

Doing social media content with intention is now just part of doing business.

Other content that does well is anything that inspires interaction. Having a reason to comment, vote, or answer a question will help that content do better.

Instagram just wants to keep people in their app, so they can sell ads. So having a good user experience is ab onus. Once you can help with that, they will start organically rewarding your account.

If you go against that, like linking many people outside of the app, they will punish your content.

If I post a piece of content with a link in it, or have lots of people going to my profile to click a link there. That content will always do poorly. For links on Stories, my posts will typically do about one fifth as good as a normal piece of content. Even if the content gets reshared a lot.

If you're looking for a full monthly Instagram content calendar that takes a lot of this into account, there is one in Book More Weddings 2023 at www.taylorjacksoncourses.com.

When it comes to Instagram, and all social media. It's important to understand that your goals might not be the same as someone else's. You don't need 100,000 followers to have a successful business. But, five hundred people paying attention will do more good for your business than 100,000 loose connections.

Let's move on to Facebook.

32

Facebook

A lot of people will say that Facebook is dead. That no one is on there anymore. I don't think that's the truth. There is still a very large user base on the platform. Just because people in a certain area of the world might not be using it as much as they once were, it doesn't mean the platform is dead.

Currently, Facebook Reels are getting a huge amount of organic traction. More than I've seen with Instagram.

Being open, and able to see new opportunities is important in business.

The 30+ year old crowd seems to be the dominant user on Facebook now, which means while there are still couples getting married, the age is trending up.

As I mentioned in the past chapters, it's a great place to run paid ads to capture the moms that want to book family sessions.

In Book More Weddings 2020, I discussed a new strategy. To target the moms of couples on Facebook.
I had success with this. Writing copy and making a video to get them to share my photography website with the couple. This worked well, and continues to today.

Same rules apply to Facebook as Instagram. Video content is generally preferred.
Facebook's subtitles seem to randomly come on and off, so when making video content, I will usually put the subtitles in the actual video.

If you're using Premiere, there's now an automated way to do this in captions. Other systems I suspect, will have something similar.

If it's a shorter piece of vertical content, you can always load it into an Instagram Reel post, and have it make the captions for you. Then download that file to bring over to Facebook.

For Facebook, one of the differences is that I tend to have good interaction on longer form

content. As a result, the attention span seems a little longer for things people find interesting and valuable.

I have a business page, and Boosted Posts from the page are easy. If your Facebook Business Page and Instagram accounts are connected, your Boosts can also post to Instagram and Messenger if you allow them to. Making it pretty easy for that one piece of content to get to a few different places.

In ads manager, you can also set up a Meta Pixel.
You put this on your website, and you can track who clicked. From there, you can retarget that audience.

Say over January, five hundred people clicked through your ad. Maybe three hundred of those couples didn't yet have a venue and a date, so they weren't thinking seriously about a photographer.

Targeting them again with a retarget a few weeks later will give them a much better chance of booking with you. You're a familiar person, and they might have forgotten to write your

name down. Couples have a lot going on when they first get engaged.

Another thing I talk about in Book More Weddings is having three points of contact to get a booking.

Hitting a couple with a single targeted ad might get you the booking now and then. However, what's really powerful is that paid ad being the third place they see you.

Maybe they see you on the venues page on Instagram, then a friend mentions that you shot their wedding, then they click the paid ad. By that point they're very warmed up to, and are significantly more likely to book.

Being around in many different places increases your chances of being in front of them at the correct time.

Early wedding plans are usually a mess. Maybe they're going to be having a destination wedding, but then they realize that all the family can't travel. So they decide to get married back home, and have a different wedding date. Most couples will wait to get all that out of the way

before sending through an inquiry. For this reason, retargeting is very powerful.

So set up your Meta Pixel and use it in your paid ads. At the point of writing this, you can only retarget properly from a standalone ad. Trying to do it from a Boosted post is still a bit messy. Hopefully they clean that up, because I'd love to easily set those campaigns up in a few clicks.

Facebook, like Instagram, it's key to make valuable content that people want to interact with. Content that people find valuable. I recommend summarizing some of that value on the Facebook post, and then getting them over to your website once they're interested.

In the paid ads chapter, we discussed how watching, reading or liking the ad doesn't cost you a lot of money. Usually pennies. What does cost you money is when they click through to the link you have in the ad. For this reason it's important to ensure they're a good and qualified lead before getting that click through.

Your ad dollars will go a lot further this way.

We also talked about doing $5 per day in paid ads. You can split that up with Facebook and Instagram if you want to try it out, or add a few more dollars to test out Facebook. Retargeting is valuable and something you sure for sure be using.

33

Pinterest

Pinterest is big in the wedding planning space. Outside of that, I don't know too many power users of it. I like how easily the content you post here will rank on Google and in Google image searches.

I don't have an experience with paid ads on Pinterest, but I encourage you to try them out if they seem interesting. For example, if you have a few good wedding images that you promote, they could find their way onto many different wedding boards, and continue to bring in clicks for years.

You can also create style boards here to send to couples for engagement session ideas. Lindsay does this for outfits. In addition, she has boards for family session, engagement sessions, and newborn sessions.

It's easy to get couples on the same page as you.

It's worth posting images here for how easily they're indexed by Google and organically how they'll end up on couples' inspiration boards. Of course, venues will collect images here as well.

34

TikTok

TikTok's massive advantage is local reach. They also now support image carousels, which works well for us as wedding photographers.

I have a full TikTok course for members, and I'll mention some things here.

While TikTok came up on entertaining content, there's now a huge market for educational content. So I would suggest making educational video content to a local audience.

Start videos and hooks with visuals local people will recognize. Wedding venues, or your downtown area.

TikTok isn't new at this point, but there is still an opportunity in most markets to be the first wedding education person. Sure, some people have probably done a few small pieces of content, but it's unlikely someone has focused a few months on that content style.

In terms of age, TikTok is a much younger demographic than Facebook. This means if you spend some time creating content and developing an audience, it will hit the correct market for years to come.

While TikTok will try to convert you to someone that posts ten times per day. You don't have to. A business like wedding photographer is a marathon and not a sprint. By creating one or two useful pieces of content per week you'll make fifty or one hundred videos in a year. When someone local organically comes across one video, they'll be shown a lot of similar back catalogue content.

Find a sustainable way to create TikTok content because it will burn you out if you let it.

One struggle I have with TikTok is getting people off of the app, and to your website. So make a clear call to action at the end of each video to visit your site for even more useful information about planning a wedding in your local area.

When it comes to hashtags, I like to stay targetted to my ideal couple, and don't use the

bigger hashtags. While it might be nice to get some vanity views, those people won't stick around for longer videos, hurting that videos organic reach.

Another huge plus of TikTok, is that every video seems somewhat independent of one another. So if you upload a bad video that doesn't get shown to anyone, that doesn't affect the next one.

TikTok works similarly to Instagram in the way reach works.

First the platform will show a few users. Likely those are following you, or a few currently interested in the topic.

If those users react positively to the content, it will show it to a larger group. A lot kind of summerize this in round numbers to keep it easy.

You upload something to TikTok. It shows it to one hundred people. If those one hundred people have a positive interaction, TitTok shows it to the next group of one thousand people. If successful there, it goes to the next tier of ten

thousand. Then 100,000, then one million. These have been my experiences as well.

I have a few one million + videos, and a ten million+ video that still continues to generate views and interaction every day.

I find this to be true with Instagram Reels as well. If you make a good Reel that people share, it will continue cycling that Reel into a viewers mix even if it's an old video. The key is that you need a new video for them to interact with, so that it will then show them more content from you.

I've had videos from months ago randomly gain a lot of traction because of this. However, when I posted it, maybe it wasn't the right time. Either the topic wasn't popular yet, or maybe that day there was just too much content being posted to the platform and it didn't get a fair chance.

Whatever the reason, it's nice that content can continue to be successful long after it's posted.

If you enjoy, and understand TikTok, it might be your place.

35

YouTube

I've spent the past number of years creating content for YouTube. But, unfortunately, it's not in the space that we're going to talk about today.

I create travel content, photography education and gear reviews. Unfortunately, these things don't book many weddings.

Here's what I would do on YouTube now if I had the time.

I would be creating value rich locally based helpful content. I would create it around search terms I know local couples are typing in.

You can even go to ChatGPT and ask it to give you twenty titles for YouTube videos about whatever topic you want to make a video about. Then pick the best one.

As weird as it is, you have to start with the title, and sometimes the thumbnail for YouTube content. Those are key for getting the click.

The good news is that Google owns YouTube, so there's a good chance when couples are searching, they will see video search results above other text blog posts.

For every established venue in your area, there are probably over one hundred blog posts with text and image based content, but very few have made that into a video.

You also get to embed that video onto a text page. Together the pieces of content will rank stronger than just one on their own.

With YouTube you could play a lot of other marketing strategies that no one else is doing.

You can do venue walkthroughs and tours. You can interview other wedding vendors. You can do a behind the scenes wedding day with a venue, or a vendor. You can talk about how to plan a perfect wedding. Then, you can break it up to smaller content like five Things I Wish I Knew Before Having My Wedding In City Name.

There are a lot of options for video content. These pieces of content can also be made into shorter verticals and text content for your blog.

Another big piece of content I don't see many people doing is behind the scenes wedding days, but targeting the venue they're at. I think this is a huge missed opportunity. Couples are very interested in seeing an actual wedding day at the venue they're choosing.

If I were in my first years of wedding photography, I would be trying to make a ten to twenty minute behind-the-scenes video for every one of the weddings I photographed. After years of doing this, you'd have a lot of venues covered with a unique piece of content that no one else is doing.

Bringing this back to talk about social media, you'll notice that creating for one platform usually creates content for most platforms. So, starting with something like a YouTube video, can trickle down into all other platforms including your traditional blog.

36

Mindset, Marketing, and Attracting Ideal Couples

Marketing a wedding photography business is a weird task. It's not something you sit down for three hours to do on Mondays. Instead, it's always on your mind, at least a little bit.

When a couple is looking for a photographer, it's such a small window. While it might seem like social media should be there to get the click to your site and make the sale. It rarely works out like that.

What social media is, for me, is a long game. It is about connecting couples to me, the person behind the camera.

The landscape of what a wedding photographer is has shifted so heavily over the past few years. Looking back, even five years ago, if you were a slightly above-average photographer, you could book work based on your skills.

As great photography becomes easier to make, the market is becoming even more saturated with photographers I consider excellent.

It's great to see the industry reach a new level of quality, but from a business standpoint, things are more complicated.

More than ever, couples are looking for a photographer they connect with and one that fits their social status tribe. Great work is a prerequisite to doing business. The sale gets made in the connection with your couple.

While it's possible to create a connection in the hours or few days a couple is actively looking for a wedding photographer, it's rarely the case. Photographers that book the most work are always playing the long game.

This means that successful photographers are showing up for their brand and themselves every day on platforms like Instagram Stories.

The photographers I see doing the best do interesting things in the local community. They're creating content each day to align themselves with their tribe. They know that one individual Reel isn't going to book them an

entire season. So it's a collection of all the content they produce when someone is paying attention.

How do you get people to pay attention? There's a simple answer. Deliver value over a long period of time.

What value is will be different for everyone. It can also be a combination of many things. For example, it can be educational, entertaining, or interactive.

An Instagram story of a lunch you ate brings no value to the viewer. Contrast that with you going out of your way to test five pizza local pizza shops and rank them. Then you make a Reel with the results. That's interesting, brings value, and will be shared.

There is now an element of being a professional social media personality in a successful photography business.

There's also a good chance that many of your local competitors don't want to do this. They might reject this new shift if their businesses have been established for a while. That leaves space for you to gain more market share.

You will win if you understand how to bring value to your audience. The more value you bring, the more your audience will grow.
If you bring value to wedding venues, you will be on the preferred vendor list faster.
If you bring value to other vendors, you'll always be the first referral on their minds.

Rather than thinking about how I make more content, think about how you can generate more value for others with my time. Then, when you create from a place like this, you will succeed.

37

Closing Thoughts

With wedding photography, building a business that makes you happy is important.

I've met a lot of burnt out wedding photographers. Happy they get to use a camera to pay the bills, but have lost the passion for weddings and their business.

If from the start you're intentional about making the choices that make you the most happy, you will create a business of your dreams.

The parameters for what your wedding business is can change as you wish.

If you want to book ten local weddings, and ten destination weddings this year, that is a thing that is within your control.

Do you want to book seventy weddings this year and then take a full year to travel the world next year? Go ahead.

If there are elements of your wedding business that you don't enjoy, you can hire to fill those spaces. Don't like doing your taxes? Hire someone and put the time you saved towards booking another wedding. Even though it seems like a short term loss to spend the money, you are buying back your time. You can use it to profit more, or just relax.

My first few years in business were a struggle. Working with non-ideal couples has a big mental impact. It will make you second guess your journey.

Know that when you start working with your ideal couples, everything turns around. First, you're excited to go to work. Your couples are excited to see you.

Going back to the six human needs. You can find everything in wedding photography.
1. Certainty. You want to know that you have enough money to put food on the table. That jobs are coming in.
2. Variety. All your weddings are a little bit different, and if you get sick of weddings you can do more family work or commercial.

3. Significance. You're doing something that your couples and the venues appreciate. They go out of their way to make you feel special.
4. Connection and love. You're going to meet so many incredible people in the wedding industry that will become life long friends.
5. Growth. You're going to grow weekly as an artist and a business owner.
6. Contribution. You're contributing your time, and creating memories that will last generations.

Working for yourself also comes with the advantage of completely controlling your schedule. Again, this is something I value highly.

You're no longer forced to go to the grocery store on a busy Saturday morning. Instead, you can go Tuesday afternoon.

There is still work to do, but it's the long game. Very few things are urgent, and your week can be laid out as you choose.

I'm happy you were serious enough about this journey to make it to the end of this book.

If you want to get into more of my videos, I have a lot on my YouTube channel, or you can get into the member's site over at www.taylorjacksoncourses.com
Hundreds of hours of courses and other content will help you get your business to the place you want it even faster.

Until I see you again, I'm Taylor Jackson, and thanks for reading.
If you enjoyed this book, please leave a review of it where you picked it up.

Find Taylor Jackson:

YouTube:
http://www.youtube.com/taylorjacksonphoto

Instagram:
https://www.instagram.com/taylorjackson/

Full Length Courses:
https://www.taylorjacksoncourses.com/

Focal Websites:
https://www.bookfocal.com/taylor